CW00546814

HAYLING ISLAND

A PICTORIAL ACCOUNT OF THE ISLAND
EMBRACING THE EARLY YEARS OF PHOTOGRAPHY

JOHN ROWLANDS

The
History
Press

First published 2013

The History Press
The Mill, Brimscombe Port
Stroud, Gloucestershire, GL5 2QG
www.thehistorypress.co.uk

British Library Cataloguing in Publication Data.
A catalogue record for this book is available from the British Library.

ISBN 978 0 7524 8623 9

Typesetting and origination by The History Press
Printed in Great Britain
Manufacturing managed by Jellyfish Solutions Ltd

CONTENTS

PREFACE

My association with Hayling Island began in 1955 when, while living in lodgings in Havant, I joined the Seacourt Badminton Club. There I met Joan Davies, a teacher at Hayling School. Three years later Joan and I were married and we set up home on Hayling. One of my interests was photography and as an active member of Hayling Camera Club in 1964, I was persuaded by fellow members Mike Rolfe and Lionel Marten to collaborate in a project to make a collection of 'Old Hayling' photographs.

Michael J. Rolfe at that time was a civil engineering student at Southampton University, while Lionel Marten was a local dentist. Michael arranged to publicise and finance the project with a series of short articles accompanying photographs entitled 'Hayling Then and Now'. The surplus funds were used to finance the purchase of equipment for the Camera Club, and for the production of annual slide shows which entertained the Camera Club and a number of other Hayling clubs and societies.

As a local dentist, Lionel was ideally placed to extract any original photographs he could obtain on loan for copying from his patients. My role was to modify an old half-plate camera to take a lens extension for close-up photography, and later to adapt the camera to take a 2½ x 3½ inch roll-film back made from a bellows camera – which was best described as beyond economic repair! Using this modified plate camera, I copied over 300 photographs, pictures and engravings – their final quality was dependent on the state of the originals. Attempts to copy photographs originally taken with box cameras from the 1920s and '30s were not very rewarding. However, the project raised much local interest and the images were put on show in 1967. A few years later, an enthusiastic history master at the Hayling Secondary School arranged with the Camera Club to take the photographs on permanent loan for use in local history studies. Two sets of the better-quality prints were made for the local library and the Hampshire Records Office in Winchester. As photographic negative plates and film are not ideal for safe storage, I made a further set of prints for myself.

In 1971 my employer decided to transfer my section's work to Dorset, and very reluctantly Joan and I moved home, but we frequently returned to Hayling to visit friends. However, that all changed in 1976 when tragedy struck and Joan died of cancer. From then on my fond memories of Hayling were tinged with sadness, and so it was time to move on. Very rapidly my contacts with Hayling diminished and for many years now I have had no involvement with the island. Having become an octogenarian, I decided to salvage my set of the Old Hayling Collection from the loft, with the intention of making it available to the public. Not surprisingly my efforts to locate the other three sets of the collection have not been successful. This has spurred me on to preserve the best of the Old Hayling Collection in book form, readily available for all to enjoy, should they wish. With the passage of time and

the development of computer technology, I have had the opportunity to digitally enhance the images; it has been a time-consuming occupation, but very enjoyable.

In the course of making the Old Hayling Collection, we were loaned a copy of the *Hayling Island Guide and Handbook* published by Green & Co., of the Seafront, Hayling Island, in 1922. It contained a section of 'Historical Notes on Hayling Island'. These notes contain a reference to a previous chapter so they were obviously extracted from a larger book, probably one of the several local histories produced on the hundred of Bosmere. The short history reproduced here is, I believe, an excellent summary of the island's past and it is hoped its republication will make it accessible for some years to come.

The oldest images, in the form of engravings and drawings, date from around 1820. The photographs dating from 1855–1967 cover the period from soon after the invention of photography to the beginning of the significant development of Hayling, which occurred after the building of the new road bridge linking the island to the mainland in 1956. The 1960s were the start of big changes in the character of Hayling. The demise of the holiday camps, due to the introduction of cheap package holidays abroad, led to the residential development of the sites and a large increase in population. It was our original intention, on completion of the Old Hayling Collection, to embark on a project to record Hayling in the late 1960s, but at the time we did not foresee the urgency – or the sudden departure of Michael, Lionel and myself. Consequently this second project was not pursued seriously. With hindsight, I now realise how interesting a pictorial record of the development of the island from 1970 would have been, especially for the seafront, and Mengham shopping areas which are now, to me, almost unrecognisable.

The photographic collection was last shown to the public in 1967. At that time it amounted to 192 pictures not subject to copyright. Since then a further thirty-nine photographs have been added, with another fifty photographs which cannot be published as they are subject to copyright until 2039. An attempt has been made to present the pictures in some logical order, commencing with: Offshore and the Beach; Beachlands; East Hayling; Mengham; West Town and Manor Road; Stoke; and North Hayling. Identifying the location of all the pictures has not been possible. I can only claim to have done my best! Another contention was the wording of the captions: in the course of the last 200 years places and buildings have changed names. Hence, where known, the names used for the original images have been reproduced. Editing this collection has brought back many happy memories of the island for me; I hope that the reader will get much enjoyment from this book, and like the author recall many happy memories of the island.

John Rowlands, 2013

ACKNOWLEDGEMENTS

My sincere thanks go to the residents of Hayling who loaned images for copying to compile the 'Old Hayling Photographic Collection' namely, Mrs Bursby; Mrs Hammond; Mrs Ranger; Mr Cole; Mrs Hayler; Mr Rayment; Miss Colebrook; Mr A. Heaney; Mr J. Smith; Rear Admiral Dolphin; Mrs Hill; Mr Stokely; Miss Fleming; Mr Marten; Mrs and Miss Trigg; Mr Fly; Mrs McLeod; Mrs Tucker; Mrs Fox; Mr North; Mrs S. Usherwood; Mr Green; Mr Pope; Mr Warren; Mr E.H. Gridley; Mr Pratt; Mr Gutteridge; Mr Pyecroft; Hayling Women's Institute; and Stoke Women's Institute.

Many thanks also to Oonagh Beasley, my son David Rowlands, and my daughter Sue Verstage for correcting the draft and proofs, and to The History Press commissioning editor Nicola Guy for her technical help in the preparation and presentation of this book.

Overleaf: A map of Hayling Island in around 1840. Even the few roads shown on the map at that time were probably constructed of gravel from the seashore, and the first bridge to the mainland was not completed until 1824. In the 1801 census, the North parish had forty-two houses and 254 inhabitants, while the South parish had fifty-four houses and 324 inhabitants.

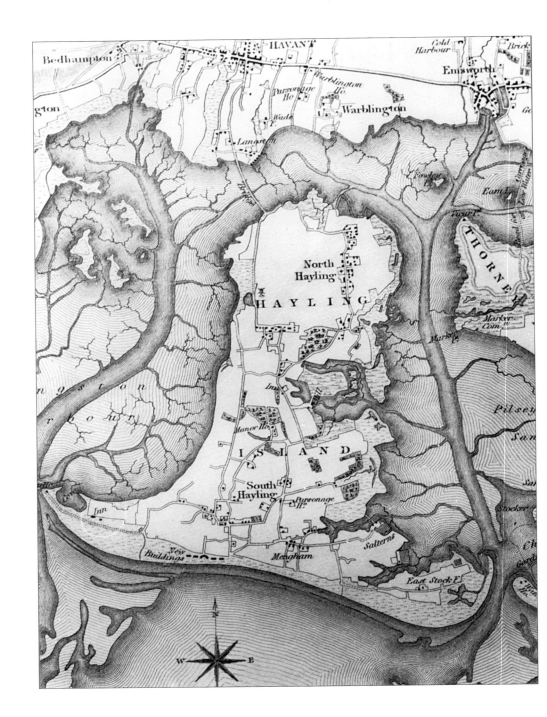

HISTORICAL NOTES ON HAYLING ISLAND

FROM A GUIDE AND HANDBOOK PUBLISHED BY GREEN & CO., SEAFRONT, 1922.

(AUTHOR UNKNOWN)

[Where archaic terms are used or more relevant information has become available since the original publication, explanations are shown in italics.]

Although Hayling does not figure prominently in the great events that are common knowledge in national history, there is so much that is picturesque and even romantic to be found in a survey of its past, that an extended chapter may not inappropriately be devoted thereto. Particular interest is aroused by the many records supplying evidence of the customs and conditions of feudal and mediaeval days, when its relative prosperity and importance was probably greater than at any other period.

The court rolls of the manor, extending backward to a very early period, are preserved, some in the tower of London, some in the Rolls Chapel, others in the custody of the Duke of Norfolk, and the steward of the manor; while other records in the British Museum also throw light on the course of events in Hayling's past history.

PREHISTORIC CONDITIONS

The early Britons have left many traces of their occupation on the mainland immediately surrounding Hayling Island, and relics of Palaeolithic man discovered on the island itself, may be seen in the Portsmouth Museum. It may safely be inferred that the Germanic tribe of Belgae who landed and settled on the southern coast of Britain – doubtless attracted by the facilities afforded for the pursuits of hunting and fishing, and contiguity [*close proximity*] to the sea – did not overlook a spot so eminently suited to their mode of life.

From the quantity of timber still remaining, and the much greater quantity it is known to have contained formerly, there is every reason to believe that the island was once a perfect forest. The old names of Stoke, Eaststoke, Northstoke, Southwood, Northwood, which still survive all appear to indicate a forestal region, and that wild boar and deer were common is a probability corroborated by authentic facts in similar islands in the South of England. It has also been suggested that Westney, which in old records was West Hay, was derived from the term signifying a hedged or paled portion of a wood into which beasts of warren [*animals or fowl*] were driven for capture.

ROMAN OCCUPATION

From a very imaginative picture of the pre-historic population and conditions of Hayling Island, we may pass on to later days, and authentic data. Conjecture gives place to certainty with the period of Roman occupation of Britain. About AD 47 Vespasian, in command of the second legion under Aulus Plautius, reduced the Isle of Wight and twenty towns in this part of the country to subjection and Chichester, under the name of Regnum, became a military station of importance.

Though Porchester, to the west, would seem to have been chosen as the site for the fort and arsenal, it has been regarded as probable that the main Roman army under Aulus Plautius, who opposed Caractacus, landed partly in Hayling and Selsey. The shores and waterways were almost certainly utilised for the landing of reinforcements and supplies. Moreover, the comparatively recent discovery of the remains of a Roman villa about a quarter of a mile from North Hayling railway station attests the fact that the Imperial conquerors realised the residential charms and advantages of the island equally with the favoured visitor of twenty centuries after. Excavations have brought to light a tessellated pavement of Roman workmanship, together with other relics, such as coins, a signet ring, funerary urn, pottery, etc., one of the coins bearing the inscription 'Caesar Augustus', and a small token, bearing the name of 'Faustina', who was the wife of Antoninus Pius, the Emperor who succeed Hadrian in AD 138. The building was doubtless neglected and fell in ruin after the departure of the Romans, finally becoming submerged under the soil.

There are grounds for supposing that Tournerbury, in the southeastern part of the Hayling Island, may be a Roman camp. This occupies a rising ground forming almost a circular vallum [*embankment or rampart of earth or stone*] with a diameter of 200 to 250 yards, surrounded by a fosse [*ditch*] which could be filled with water from Chichester Harbour. The vallum is about six feet high and the fosse apparently the same depth, but erosion of the banks and accumulations of leaves and vegetable matter have apparently filled it up. The interior space contains about three acres and upon the vallum are a number of very ancient oak and yew trees, perhaps coeval with [*of the same age as*] the formation of the embankment. No traces of any building, nor bones, nor fragments of any kind to testify to its purpose, however, have yet been found within this space to add evidence of its origin or appropriation.

Traces of a supposed Roman road have been discovered leading from Tournerbury for some distance in an easterly direction.

The name Tournerbury is doubtless of later application, and appears to be derived from the Tourn, or great court leet of the county, at which the sheriff was the judge, and from which only certain privileged persons were exempt from attendance. It was enacted by Magna Carta that no sheriff should make 'his tourn through a hundred but twice a year', once after Easter and once after the feast of St Michael. The general attendance of all men in the neighbourhood ceased to be required about the reign of Henry III, and a sworn jury acted for the public body. The sheriff's tourn was held in Hayling down to the year 1781.

THE SAXON CONQUEST

Following the withdrawal of the Romans, the Jutes and Saxons descended upon the coast and obtained a footing on the Isle of Wight and at West Wittering on the mainland east of Hayling Island. No comment need be offered on contemporary life in the Island. While Aella and Cissa were mercilessly exterminating the Britons in founding the kingdom of the South Saxons, and Cerdic and Cymric, advancing by way of Southampton Water, established, with the same ruthlessness, the high destiny of Wessex. In the fierce contests that followed for possession and supremacy among the Heptarchy [*seven rulers*], Hayling lay about the borders of these two kingdoms, and it may be imagined was not exempt from any of the stern and bitter experience that preceded the union of the English in Britain under Egbert as supreme king in Winchester, and the displacement of the pagan faiths of the conquering peoples by Christianity.

EARLY ENGLISH

In existing records Hayling Island first comes to notice in 1043 as a possession of Emma, wife of Ethelred the Unready, and afterwards by Canute, and mother of Edward the Confessor. The authenticity of this early document has been doubted, and the quaint legendary character of parts of the story related perhaps detracts from its historical authority. It does, nevertheless, purport to explain the circumstances under which the monks of Winchester obtained possession of the manor of Hayling. This medieval manuscript, entitled 'Annales Ecclesia Wintoniensis', quoted in Wharton's Anglia Sacra, dramatically relates how Edward the Confessor was induced by Godwin, Earl of Wessex, and Robert, Archbishop of Canterbury, to accuse his mother of endeavouring to prevent his accession to the throne, of consenting to the murder of her younger son, and of criminal intimacy with Alwin, Bishop of Winchester. Queen Emma, through the bishops who were faithful to her interests, demanded a public trial by ordeal of fire. This ordeal, employed for many centuries as a test of guilt, consisted in the accused person walking with bare feet upon a number of red hot ploughshares. The queen under-went this ordeal at Winchester Cathedral in the presence of her son, Edward the Confessor, and a number of bishops and nobles. We are told that in a vision she saw St Swithun, to whom the cathedral church is dedicated, and that the saint promised her immunity in the ordeal on condition that she forgave her son his accusation of her. Appealing to heaven for deliverance, the queen pressed upon nine red hot ploughshares with the whole of her weight of her body without feeling the heat. The miracle moved the king to tears of contrition and prostrating himself before his mother he implored her forgiveness.

In gratitude for the supposed intervention of providence, the monks of Winchester were enriched by gifts of twenty-one manors by King Edward, Queen Emma and Bishop Alwin, among those bestowed by the Queen being 'Haylynge'.

It is possible that Queen Emma originally became possessed of Hayling from her husband the Danish conqueror, King Canute, who built a castle at Bosham to the north-east of Hayling. Bosham is a place of very early history and legend and

the ancient church still contains the reputed tomb of the daughter of Canute. In the opening scenes of the historic Bayeux Tapestry, Bosham is shown as the place from which King Harold sailed past the eastern shores of Hayling on his ill-fated voyage in which he fell into the hands of the able but unscrupulous Duke of Normandy.

DOMESDAY BOOK

Harold himself held possession of a part of Hayling, as the following entries appear in the Domesday Survey Book of 1086:

King's land in the Boseberg Hundred: The King himself holds in Halingei two and a half hides. [*A hide was approximately 100 acres*] Leman held them of King Edward in parage [*jointly*]. Harold took them from him when he seized the kingdom and included them in the sources of the Crown farm; and this is so still. It was then assessed at two and a half hides; now for nothing. There is land for one and a half ploughs. In the demesne [*lordship*] is one plough, and there are one villein [*villager*] and eight borderers [*smallholders*], with half a plough, and one and a half acres of meadow. In the time of King Edward it was worth forty shillings, and afterwards twenty shillings; now seventy shillings.

Lands for the support for the monks of Winchester in the Boseberg Hundred: The monks of the bishopric of Winchester hold Helinghei. They always held it. In the time of King Edward it paid geld [*tax*] for five hides; now for four hides. There is land for two ploughs. There are eleven villains with three and a half ploughs, and one acre of meadow. There is woodland worth one pig. In the time of King Edward it was worth one hundred shillings, and afterwards four pounds; and now it is worth four pounds ten shillings.

Land of St Peter of Jumieges in the Boseberg Hundred: The Abbey of Jumieges hold Helingey. Ulward White held it of Queen Eddid as an alod [*freehold*]. It then paid geld for twelve hides; now for seven hides. There is land for fourteen ploughs. In the demesne are two ploughs; and there are twenty three villains and thirty seven borderers with seventeen ploughs. There are three serfs [*slaves*], and a salt pan worth six shillings and eight pence, and two fisheries worth twenty pence, and one acre of meadow. There is woodland worth twenty swine from the pannage [*pasturage*]. In the time of King Edward it was worth fifteen pounds, and afterwards ten pounds. It is now worth twelve pounds, but it pays a rent of fifteen pounds.

The monks of the bishopric of Winchester claim this manor, because Queen Imma gave it to the Church of St Peter and St Swithun, and at that time gave the monks seisin [*possession*] of one half; the other half she demised [*granted*] to Ulward for his life only on condition that, on his death, the monks should have his body for burial and the manor also. And on these terms Ulward held his part of the manor of the monks, till he died, in the time of King William. This is attested by Elsi, abbot of Ramsey, and by the whole Hundred.

The variation in the rendering of the name in these records is particularly noticeable, and it is difficult to trace its original derivation. It was at one time Haring Ey, the 'Ey' believed by some to denote an island. Another suggestion is that it is derived from the Saxon 'healle, inge, and ey', signifying the place of the meadow in which there was an aula or hall, answering to the modern hall or mansion, or again, as islands were considered objects of sanctity, from the Saxon halig, signifying holy or sacred. Perhaps akin to Heligoland. In the tenth century it was called Heglingaig; in the eleventh century Heilineiga, Halingei or Helingey; in the twelfth century Hailinges or Haringay; and the thirteenth century Heyland or Heling.

[*For a more modern translation of the Latin text translated from Anglo Saxon and printed in 1783, the reader is referred to the 1983 translation Domesday Book: Hampshire: No. 4, edited by John Morris and published by Phillimore*]

THE THREE MANORS

It is difficult to define the limits of the three divisions of the island mentioned in Domesday and the difficulty is accentuated by the diminution of the extent of the island itself from causes which will be referred to later. But it seems that the four hides of the monks of Winchester was coterminous with [*the same as*] that portion of the present parish of North Hayling now lying within the manor of Havant.

The manor of Eaststoke, Northstoke and Westhay included the south-east corner of the island with other detached portions in the North parish. Eaststoke manor was granted by Edwy, in AD 956, to his servant Ethelsig and his heirs. This seems to be the same as the five hides in Hayling which, before the Conquest were held by Ulward. It was granted by William I to Earl Roger of Shrewsbury, by whom it was bestowed on the Norman abbey of St Martin, Troarn, and, in 1261, was conveyed to John Falconer of Wade. In 1304 the inheritance passed to John le Botiler and Joan, his wife, and in 1315 these two were attached to answer certain tenants or 'men of the said John and Joan of the Manor of Helinge', because they required other services than those which their ancestors had required when the manor was in the hands of the former kings of England. The tenants set forth the terms of their holdings from the time of William the Conqueror, and stated that on the death of an ancestor they used to give half a mark – instead of which the defendants now demanded one mark – for entry upon every acre of land. They also complained that the Le Botilers demanded 'ransom of flesh and blood, tallaging [*taxing*] them high and low at will, grievously distraining them from day to day.'

At the trial John le Botiler absented himself, but his wife stated her own case, and on a further hearing the tenants in turn absented themselves, and a verdict confirming the services claimed by Joan was recorded.

In 1351 the same lands in Hayling appear to have belonged to the Prior and Convent of Calceto, or the Causeway, near Arundel, and were held by a second John le Botiler as trustee for them. Through subsequent holders they passed to Sir Thomas Lewknor, who was attained in the reign of Richard III, and his lands at Hayling escheated [*lapsed*] to the Crown. In 1524 the Convent of Calceto was suppressed under a royal

license by Cardinal Wolsey, on whose disgrace their possessions passed into the hands of the Crown. The subsequent history of the descent of this part of the island has little of general interest. In 1596 we find it was conveyed to Jonah Latelais, and was next sold to Thomas Peckham, of London. Ultimately it descended to Peckham Williams, and in 1870 became the property of Mr Lynch White, of Streatham, by whom the estate was sold in building plots. The largest portion with the manorial rights was secured in 1902 by Frank Pearce, Esq.

HAYLING MANOR

The richest as well as the most extensive part of the island was undoubtedly that which passed by the grant of William the Conqueror into the possession of the Norman Abbey of Jumieges.

This once famous Abbey enshrined the remains of the Conqueror's mother, and was endowed by him with other English possessions besides Hayling. Its ruins, of exceeding beauty still exist upon a peninsula formed by the windings of the river Seine, and with the extensive country around attested the grandeur and magnificence of the house when at its zenith.

THE PRIORY

It has more than once been asserted that Hayling Priory was not founded or erected until the reign of Henry III, but this is improbable, as the abbot and convent of Jumieges would certainly have sent over a colony of monks to the island as soon as William I had bestowed on them so valuable a gift, and a cell or priory of Benedictines would have been speedily erected, with suitable buildings including a chapel or conventual [*religious community*] church. The Domesday Survey shows that the abbey of Jumieges held about half of Hayling Island in demesne, with the overlordship of the rest, by gift of William I. Their possession, however, was disputed by the monks of St Swithun, who based their claim on the grant of Queen Emma which has already been alluded to. The abbey of Jumieges, having once obtained the grant of so rich a manor, refused to give it up, and though William I confirmed Queen Emma's gift to the monks of St Swithun, Henry I regranted Hayling to Jumieges. Continuous disputes arose between the monks of the alien priory and those of St Swithun of Winchester, and eventually in 1241 a serious dispute arose between the Prior and the Vicar of Hayling. The latter claimed the tithes of the parish as belonging to his church, whilst the prior claimed them as given to the Norman Abbey by William the Conqueror. The vicar (Master Nicolas de Rye) went so far as to excommunicate the prior who was his religious superior. The prior sued the vicar at Westminster for these tithes and laid his damages at £100. As a result the vicar was prohibited from prosecution, and ordered to absolve the prior from excommunication; but, refusing compliance, he was put under restraint. Eventually he withdrew his claim to a greater amount of tithe than his predecessor had enjoyed and absolve the excommunication.

The tithe question led in the end to the intervention of Pope Innocent, who by a bull [*papal edict*] addressed in 1253 to the dean and wardens of the Friary Manor at

Winchester referred the settlement to them. This procedure reveals some curious and rather surprising points of ecclesiastical practice as between the Pope, the bishops, and the clergy of the period. The records of the proceedings show that the findings included a taxation of the vicarage, made 'with the council of prudent men', and further that the abbey of Jumieges was legally possessed of two-thirds of all the tithes in Hayling and the right of patronage under their original charter from the Conqueror, and the remaining third part, then in possession of Nicolas de Rye, who had been instituted by the Bishop of Winchester, was also granted to the abbey of Jumieges, on revision, at his decease.

Returning to the records of the early charters we find that the grant of Henry I was further confirmed by Henry II 'to the church of the Blessed Mary and St Peter of Jumieges, and the monks there serving God 'to wit, of the gift of king William of England, the greater part of the Island of Haringey, with the church and tithes of the whole island, except the tithe of pulse and oats in land of the Bishop of Winchester, and, in the same island, sac and soc [*rights of jurisdiction*], and thol and theam [*manorial jurisdiction*], and infangenethef [*power of passing judgement on anything*], with all other customs.'

The grant of 'thol' in these charters was the privilege to buy and sell, or hold a market, with the customary dues paid to the lord for his profits from a fair or market. The passage-money paid to the ferrymen at the ferries of the eastern and western harbours also passed by these charters to the Abbey of Jumieges. The prosperity prevailed throughout the island at this period may be judged by a note in the History of the Royal Abbey of Jumieges that the prior founded by the monks in the 'Island of Helling' returned them an annual income of eleven hundred golden crowns. Henry II also permitted them to carry all things from the demesne of the church freely to all parts of England and Normandy. From the accounts of the manor in the time of Edward I also it appears that the profits of the manor by the existing monetary standards at that date were considerable and among the items are 3*s* for one hundred doves, 49*s* for 114 cheeses, and 15*s* 9*d* for 21 gallons of butter.

The highly valued rights of free warren seems to have provided yet another cause for litigious [*legal*] dispute. We do not in this case find a charge which equals the quaintly grave terms attributed to a Bishop, who, in 1471, issued a mandate to one of his deans to the effect that 'certain persons, sons of damnation, seduced by the spirit of the devil, and laying aside the fear of God', having broken into his park at Selsey, and chased, killed, and carried away the deer and other wild beasts, such persons were 'adjudged to have incurred the penalty of excommunication by bell, book, and candle'; the Abbot of Jumieges was simply summoned in 1279 to answer the King before the justices itinerant at Winchester, by what warrant he claimed free warren in all demesne lands in Hayling without the will of the King and his predecessors. The verdict of the knights summoned to try the issue confirmed the abbot in his right.

At the outbreak of the French wars all the alien priories in England that were subject to the abbeys of Normandy were seized in 1294 by Edward I, the prior of Hayling being taken prisoner for a time, and the priory goods and chattels confiscated. It is probable that he, together with the heads of other alien houses,

was subsequently released on finding sureties to observe neutrality during the war. It was again seized by Edward II on the renewal of the French war, the prior on that occasion pleading before the barons at Westminster, that his house and its appurtenances [*belongings*] might be committed to him for safe custody. The crown consented to the petition of the prior, and committed to him the keeping of his house and all the issues thence received, saving to the services when they should happen to be required.

THE INUNDATION

But a far greater misfortune was in store. From the time of Edward I, the sea had been gradually encroaching on the western shore of the island, thus reducing the property of the monks, and in 1324/5 the whole south coast suffered much depredation, a considerable extent of Selsey and a large portion of Hayling Island being submerged beneath the waters, including, it is thought, the priory church and conventual buildings. It was stated that between 1294 and 1325, two hundred and four acres of arable land, and eighty acres of pasture land belonging to the priory, six virgates (about 180 acres) of land of customary tenants, namely the whole hamlet of East Stoke, with lands pertaining, as well as a great part of the larger hamlet of Northwood and its lands, had been inundated and destroyed by the sea, and that the full annual value of the possessions thus destroyed amounted to the then large amount of £42 7s 4d. Nor had the inundations even then come to an end, for, in 1340, there was further encroachment of the water, to such an extent that men then living, officially testified that they had known the first church of Hayling (which was originally in the centre of the island) standing in good preservation by the seashore, and that it was then two miles from the shore, and so deep in the water that an English vessel of the larger class could pass over it. A rocky patch in Hayling Bay known as 'Church Rocks' is traditionally connected with the site of the old church. Relief by Royal charter and remission of taxation on account of these successive inundations was granted by Edward I, and Richard II, Henry IV, and Edward IV, and, as a further relief, the inhabitants of Hayling were exempt from serving on juries at the Sessions and Assizes. This last privilege does not appear to have been rescinded, and though not claimed probably remains valid to this day. An estimate based on available evidence calculates the extent of the devastated tract as a space nine miles in length by about five in breadth. In later years the claim of the Dukes of Norfolk to all flotsam, jetsam and wrecks within three miles of high water mark, is supposed to be connected with their manorial rights over the submerged land.

Simon Dubosc, Abbot of Jumieges in 1391, retired from that place to Hayling having obtained a restoration of the Priory. With him came three monks to re-establish discipline, and they continued to enjoy the revenues of the priory until its dissolution. Abbot Dubosc was buried at Jumieges where his effigy may still be seen.

The last and final blow came with the general dissolution of alien priories in 1413, when it was seized by Henry V, and granted to the monastery of Sheen, in Surrey, remaining in their possession until the final Dissolution of the Monasteries by Henry VIII. It is possible that during this latter ownership Hayling Priory was

little, if at all, used as a residence, but that the monks of Sheen simply collected the revenue and allowed it to fall into decay. When in 1541 it was granted by Henry VIII to the college of the Holy Trinity at Arundel it was but a ruin, which was afterwards bestowed by the Crown upon the Earl of Arundel, and was permitted to pass out of sight and out of memory so completely, that now it is impossible to determine even its actual site, and we only know of its existence from the records. There is, in the British Museum, a cartulary [charter] of Sheen containing a catalogue, covering many folios, of the various evidences and charters of 'the suppressed house of Hayling Island' that had come into their keeping.

As all authentic traces of the priory had disappeared, its exact position in the island has been a matter of mere conjecture; some stating that it stood near the Manor House; others that it was at Tournerbury. Little evidence is forthcoming in support of either theory, except a few ecclesiastical names of fields, etc. around Tournerbury. It seems evident that the Grange was re-erected at the site of the present Manor House when the original buildings were threatened with inundation by the sea. Henry, Earl of Arundel, settled the manor and site of Hayling Priory on his daughter, wife of John, Lord Lumley, by whom they were conveyed, in 1580, along with the Arundel estates, to his nephew Philip, Duke of Norfolk. It remained in the Norfolk family until 1825, when it was sold to William Padwick, after whose death the greater part of the manor was enfranchised [broken up], the remainder being purchased in 1871 by J.C. Park Esq., to whose son it passed in 1887. Most of this property and the memorial rights have since passed by sale to various owners, the present lord of the manor being J.W. Simpkins Esq.

RECORDS AND EVENTS

Much interesting and copious detail of life in the 'good old days' is extant [still existing] in the court-rolls of these manors of the island and other documents. From them we may gain some idea of the extent to which serfdom placed the persons of the 'villeins regardant [attached to the manor] and 'villeins in gross [transferable from one manor to another]' within the power and at the disposal of the lord of the manor, also curious detail of the valuation produce, and livestock connected with the extensive and flourishing agricultural industry of the island. More gruesome are the accounts of the recovery for the lord of the manor of money and articles of value from bodies washed ashore, felo de se [suicides], and proceeds of wreck. With these are mingled minutes of reversions of title in quaint mediaeval phraseology, with evidence of peculiar customs and manorial privileges regarding timber, treasure trove, deodands [fines or gifts to the church or the crown], free warren, fisheries, and offences committed within the manor. Among them we find that former lords of Hayling received a fine on the marriage of their copyhold tenants [tenants who provide produce or services to the landowner], and that the widow of an intestate copyholder was admitted to his tenement to hold so long as she shall live sole, chased and unmarried, and pays one penny to the lord as fine.

In March 1757, North Hayling sustained a disaster by a terrible swift and destructive fire. Many of the houses destroyed in the space of about three hours were never rebuilt, and the number of habitations in this part remains less in the twentieth

century than in the eighteenth. On account of the distress caused, the Bishop authorised collections among the faithful for a relief fund to assist rebuilding.

In 1798 we read that the *Impregnable* man-of-war ran ashore and was lost, the Duke of Norfolk receiving his share as lord. The timbers of this ship were largely used in the erection of Sinah Farm House, which was then the Norfolk Lodge Inn.

In 1805 a vessel from Gibraltar, bound for Penzance, was refused admittance to the harbour in consequence of infectious disease having broken out among the crew. The master thereupon changed his course for Chichester Harbour, but a heavy storm came on and the ship was driven on the Poles, nearly in front of Eaststoke. She was obliged to remain in the position where she had struck, and the coast-guard had strict injunctions to shoot any who came on shore, in order to prevent the risk of infection. Provisions were passed from the shore, in order to prevent the risk of infection. This was done by means of a rope, but the pestilence increased until eventually a heavy sea set in and the ill-fated vessel broke up and foundered, all on board perishing.

Some of the industrial undertakings, described in the previous chapter, it will be seen, utilised and depended upon the rise and fall of the tide which flows so swiftly through the harbour entrances, and to this list might once have been added an ancient mill at the head of the deep inlet near the middle of the island on its eastern shore. For many centuries the full tide was impounded in a feeding pond of nearly seven acres and the ebb was diverted to the purpose of turning a large water-wheel. This venerable and extensive establishment was destroyed by fire early in the year 1877, shortly after its restoration. Its site is now used as a landing wharf, and the bed of the feeding pond has been utilised for cultivation.

Yet another link with the past which has recently suffered destruction by fire was the picturesque half-timbered building at Stoke, known as Monlas Place; generally regarded as the oldest dwelling on the island, and to have stood unchanged from Plantagenet days.

With the suppression of the monasteries, and the decay of its Priory, Hayling seems to have fallen on evil times. The population dwindled and received among its ranks a number who were driven by desperate circumstances, the activities of the press-gang, and other conditions of life on the mainland, to seek some secluded refuge in which to eke out an existence.

PRIVATEERS AND SMUGGLERS

During the French wars the enclosed harbour waters formed a convenient retreat for privateers evading pursuit in the English Channel, and the island was a notorious centre of lawless smuggling traffic. The distress prevailing during the Crimean war, and after, reduced the inhabitants of Hayling to a very bad state of destitution. Those who were left could not earn sufficient by their labour to pay for bread alone for their families. The result was that many of them resorted to smuggling and wrecking in order to obtain a living, and in this they were joined

by deserters from the Navy and Portsmouth dockyard, who found the waste lands of Hayling a secure place of refuge. Some of these smugglers became so notorious that they were known locally as the band of 'Forty Thieves' and many grim and desperate encounters took place between them and the Revenue Officers.

A legend runs that Gable Head derived its name from one of these encounters, for the band having captured one of the members who was suspected of giving information to the Revenue men, proceeded to hang him at the end of the gable of an old barn situated at the corner of Tournerbury lane. Fortunately, the preventive men came to the rescue in time to cut him down and save his life, and from this time the spot has been known as Gable Head, although the barn itself has long ago disappeared.

Various places used for the concealment of smuggled goods can still be pointed out. One in particular exists beneath the shingle bank in front of the present Public Bathing Station almost in front of the Royal Hotel. Rough weather occasionally exposes to view the remains of the brickwork of this 'Smugglers Cave', and it was at this spot about a century ago that a young Hayling man, pursuing an accomplice who had turned informer, shot and killed his own wife in mistake as she stood at the entrance.

Reminiscences of the exploits and subterfuges of contraband runners are still related by some of the older inhabitants of the island. One highly respected resident tells, among other stories, of an occasion on which he was fishing near the ferry while a fishing smack was running under sail to Langstone harbour. The revenue men from the opposite shore hailed the ship to heave to, which she did, bringing the mainsail down flapping obscuringly about the deck, while the anchor chain rattled over the side. The excise men seemed satisfied with their search, but from his point of vantage it could not be concealed from our fishing friend that the anchor chain carried overboard with it a string of ankers of brandy. Aware that he was observed, and not relishing the consequences of acting informer, he deemed it prudent to hold his peace. The sequel followed a few nights later when he was aroused by a midnight knock at the door of his house, which he opened to find an unattended keg of brandy at his feet, none the worse for its submersion, 'and very good stuff, too' he adds appreciatively.

COMMON RIGHTS

From time to time various questions regarding ancient common and copyhold rights, particularly on the South Beach, have been raised, and attempts to secure a legal regulation of the same. But the efforts of claimants to conflicting rights and interests appear to have created a state of indecision, which in the case of lands and rights of such potential public value is extremely undesirable, and it is hoped may soon be cleared up by a satisfactory pronouncement.

MODERN DEVELOPMENT

Up to the year 1825 Hayling Island was accessible only by the east, west and north ferries, and by a wade-way passable only at low water, from Langstone. In rough weather the island was therefore quite inaccessible.

An act having been passed for the construction of a bridge across Langstone Harbour from Havant to the Ferry House in North Hayling, the first pile was driven on September 30, 1822, and the bridge and causeway were opened by the Duke of Norfolk towards the end of 1825.

In the same year, as already stated, the manor, rectory, and estates of Hayling passed from the Duke of Norfolk to Mr Padwick, and the first attempt was made to popularise the island as a watering place. It was about this time that the buildings still forming an incomplete crescent on the seafront were commenced, to be followed by the Royal Hotel, the Bath House, and the building of classical design, intended for a library, but now known as Beachlands Café.

The building scheme was virtually abandoned at this stage and the remainder of the tenure of the new lord of the manor appears to have been largely occupied in fruitless litigation concerning claims to various rights.

RAILWAY CONSTRUCTION

The line of the London–Brighton and South Coast Railway through Havant to Portsmouth, being opened in 1847, afforded railway communication between the south coast and the metropolis; and in 1860 a company was formed to promote the construction of the short railway from Havant to Hayling. The original plan was to construct the railway on an embankment which would also affect a reclamation of the mud lands of the western shore and terminate at a point near the Ferry. A subsequent Act sanctioned an extension along the beach to the centre of the island and the construction of a pier and dock at Sinah Ferry. Difficulties in construction and finance prevented the line from being completed farther than from Havant to Langstone, until the year 1867, when the undertaking was revived in the less ambitious scheme which forms the present railway to South Hayling. The line has since been leased and worked by the London–Brighton and South Coast Railway Co.

Following on the opening of the branch railway, strenuous endeavours were again made to stimulate interest in the expansion of the island as a resort. Popular fancy was sought by a steeplechase meeting organised at Eaststoke, followed by the laying out of a race-course for flat racing on the beach in front of the Royal Hotel. A town-planning competition was announced for the best design for laying out two hundred acres of land for building and recreation grounds, and prizes were awarded to those considered worthy among thirty-five plans submitted. But this venture relapsed in the embryo stage, as external financial troubles appeared to have beset the leading spirit and diverted his attentions elsewhere.

From 1873 to 1876 a series of Regattas were promoted by a loyal committee and attracted considerable support from sporting competitors along the south coast. But apparently local pecuniary support was wanting and the fixture was discontinued.

Though scant success seems to have attended all past intensive efforts, Hayling has nevertheless proceeded in general development at its own increasing pace. Census statistics give the total population of the island as 578 in the year 1801; 1,038 in 1861; 2,283 in 1911; and 3,291 in 1921. Retaining unspoilt its natural advantages and charms, and at the same time progressing in the accommodation afforded for residents and visitors, its destiny must be yearly to gain favour and extend the circle of those by whom its simple and health-giving delights once experienced are never forgotten.

MORE RECENT DEVELOPMENTS - AUTHOR'S POSTCRIPT

The 1950s commenced big changes to the character of South Hayling. The building of the new road bridge in 1956 led to significant residential development still further increased by the new Havant bypass relieving the congestion to gain access to the A27 South Coast trunk road, thus making Hayling a very desirable place to live and easily commutable to work in Havant, Portsmouth and Chichester. This with the new road improvements through North Hayling led to the demise of the 'Hayling Billy' railway line and its eventual closure in 1963.

The Hayling holiday trade in the early 1950s with its holiday camps met its decline due to the introduction of cheap foreign holiday packages making further land available for residential housing. The increase in population led to the opening of three new schools, a library, a new fire station, and in the 1970s the redevelopment of the Mengham shopping centre. For some, this no doubt ended 'the good old days' when everyone had a nodding acquaintance with the other residents of the locality who on meeting would be acknowledged with a 'good morning or afternoon' greeting as appropriate. With its modern and natural amenities Hayling must still be a very desirable place to live!

1

OFFSHORE AND THE BEACH

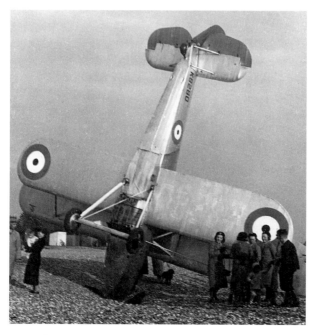

A Hawker Fury crashed on the beach in 1939 just before the outbreak of the Second World War. The ladies on the right-hand side appear to be wearing a uniform.

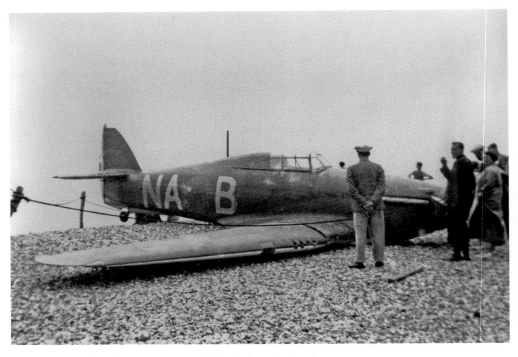

In May 1942 a Hawker Hurricane crash-landed on the beach.

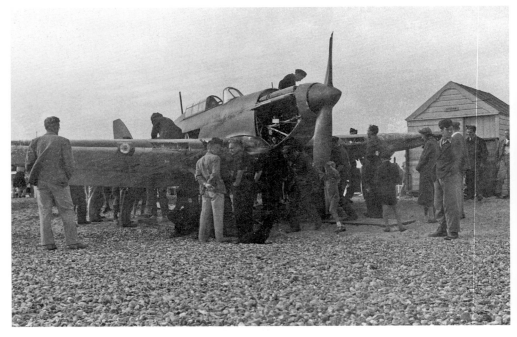

Local residents took advantage of a rare opportunity to inspect the Hurricane which, along with the Spitfire, was one of the two main aircraft responsible for winning the Battle of Britain.

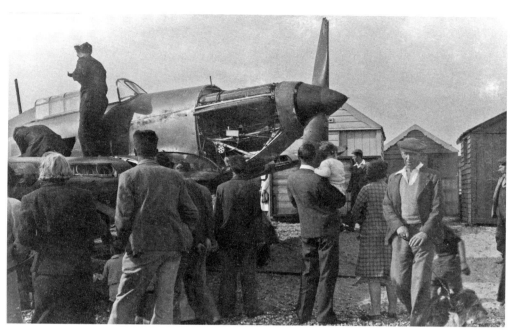

RAF engineers arrive to make repairs in situ. The problem was obviously an engine failure. It is not known whether the plane took off from the common or was transported to an airfield.

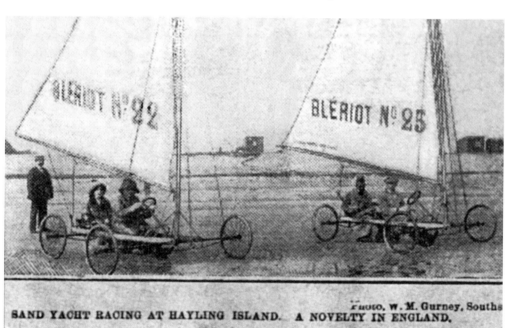

SAND YACHT RACING AT HAYLING ISLAND. A NOVELTY IN ENGLAND.

Photo, W. M. Gurney, Souths

According to the *Daily Post* newspaper on 18 September 1913, sand yacht-racing at Hayling Island was a novelty in England. Bleriot No. 22 on the left had a crew of two adventurous ladies, while No. 25 had two gentlemen.

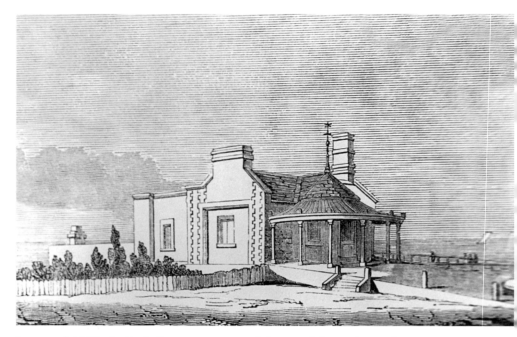

In around 1850, the Bath House was a part of the grand design for Hayling Island to become a high-class seaside resort. Changing rooms and 'hot washing facilities for those who suffer from a chill after bathing' were provided.

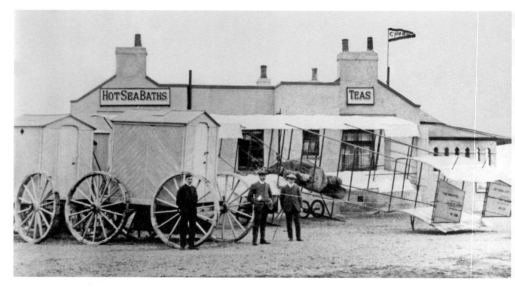

In around 1920, the Bathing House gave way to the bathing machines, which afforded greater privacy for people changing, but the hot sea water baths were still provided along with a hot cup of tea. It is not known who owned the aeroplane parked at the side of the Bathing House, but one of the rudders carries the name 'Bristol' and so it is probably connected to the well-known aircraft manufacturer of later years.

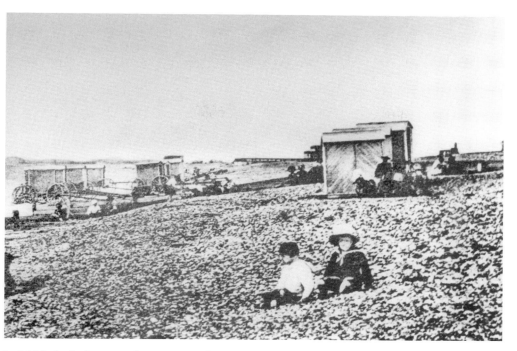

In 1910 the bathing machines were still in use but the first beach huts began to appear near the Bath House.

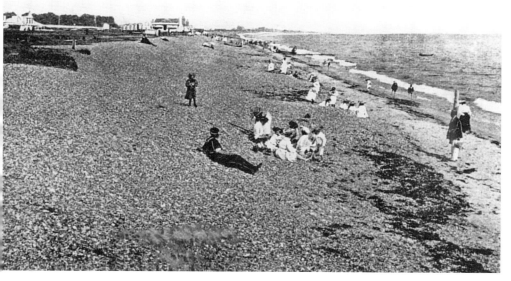

Although some are venturing into the sea for a paddle, the beach was certainly not crowded in 1908.

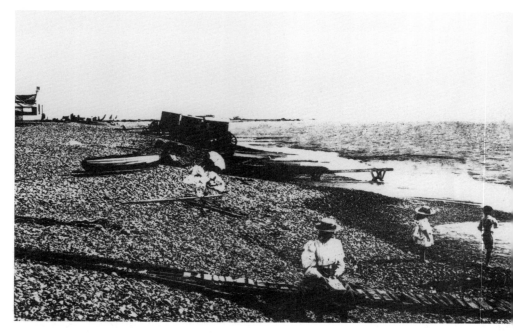

The bathing machines were moved down to the shoreline in the summer of *c.* 1910. The wooden gangway allowed the bather's to enter the machine to change without getting their shoes wet. At that time, a local authority by-law decreed that bathing without a hut or an effective dressing screen was not permitted within 200 yards of a place to which the public had access.

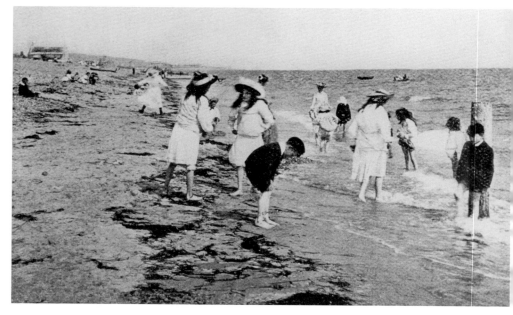

Another close-up from around 1908 shows that the ladies were determined not to get a suntan, taking great trouble to shield their faces with large brimmed hats.

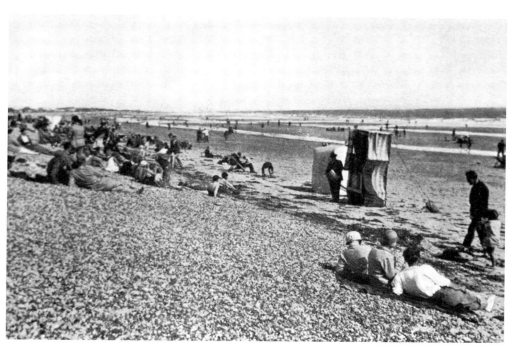

By 1925 the beach was getting much more popular and the puppet show Punch and Judy was a major attraction.

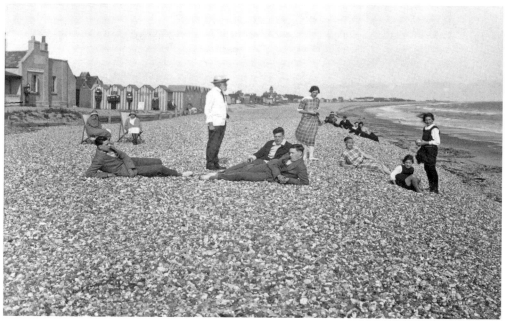

By 1926 the beach huts were much more numerous. This photograph was taken in the month of June and is clear evidence that Hayling suffered from 'typical' English weather.

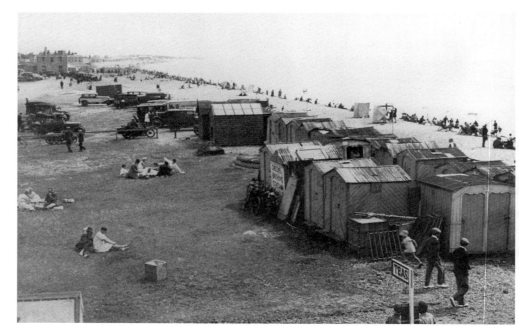

Around 1930 the beach was beginning to draw the crowds, evidenced by the early mass-produced motorcars parked on the common near the beach.

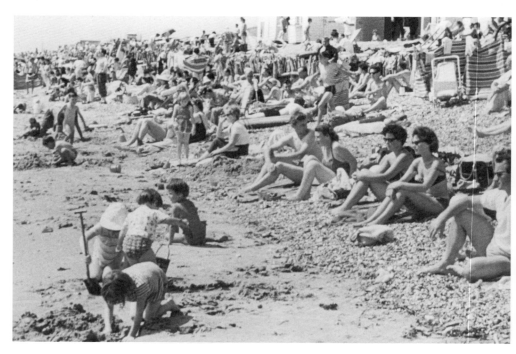

A scene in 1965 on a sunny summer afternoon shows how the beach had become a popular playground, and a suntan was a luxury for all to acquire

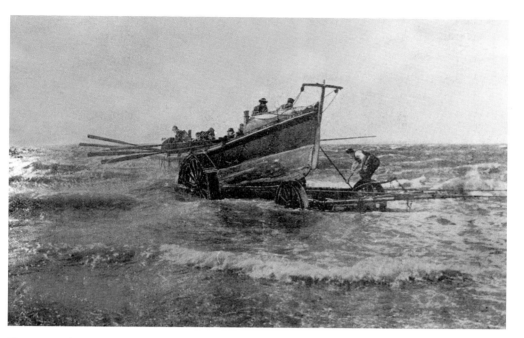

There were three lifeboats stationed at Hayling. The first, *Olive Leaf*, which served from 1865 to 1888, was a gift from Messrs Leaf & Sons of Old Change, London, in recognition of the bravery of the local fishermen who saved the lives of three crew members from the ship *Ocean*, which struck the bar at the entrance to Langston Harbour. The *Olive Leaf* measured 32ft in length, had a 7ft 4in beam, and ten oars. It was launched to four rescues, including the barque *Lady of Westmoreland* of Newcastle where eighteen lives were saved and also the barque *Atlas* in 1865, where fourteen lives were saved. Then, in October 1870, the lifeboat saved the brig *Lisbon* and her crew of seven.

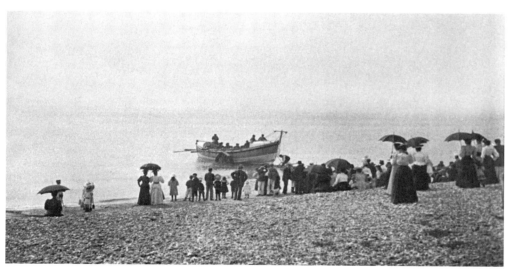

The second lifeboat, the *Charlie & Adrian*, which served from 1888 to 1914, was a gift from L.T. Cave. It was launched on twenty rescue missions, and saved nine lives.

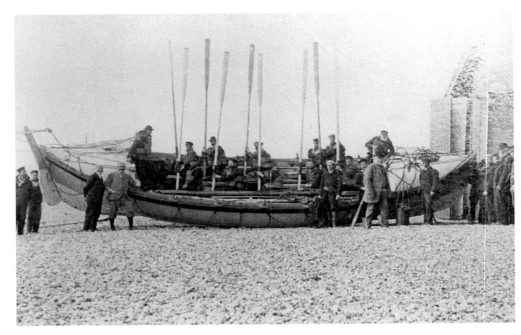

The *Charlie & Adrian* was 34ft 1in long, and had a 7ft 6in beam and ten oars. It was built by Hansen & Sons of Cowes, Isle of Wight.

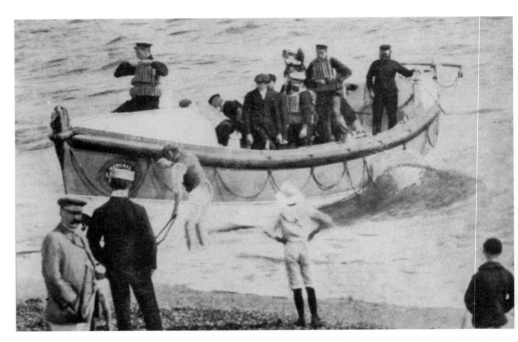

The third and last lifeboat from 1914 to 1924 was the *Proctor*, a gift from J. Proctor of Newcastle-on-Tyne. It was 35ft long and had an 8ft 10in beam. Building was commenced by Thames Ironworks of London, and completed by S.E. Saunders Ltd of Cowes, Isle of Wight.

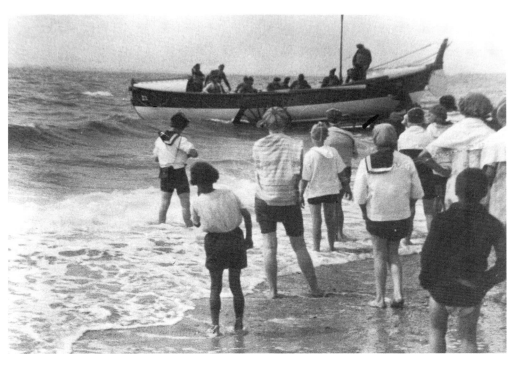

On one occasion sometime around 1920, the *Proctor* was launched with the help of the girls from a boarding school on the seafront.

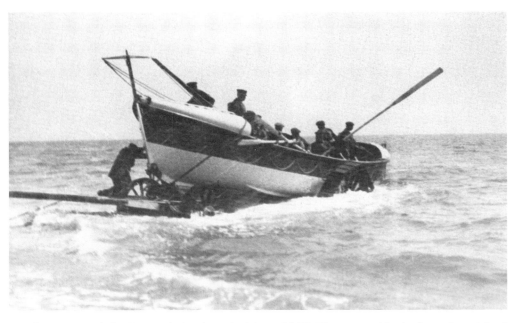

Another image of the *Proctor* being launched in *c.* 1920. The man with the hazardous job of releasing the lifeboat from the launching trolley was affectionately known as the 'knocker off'.

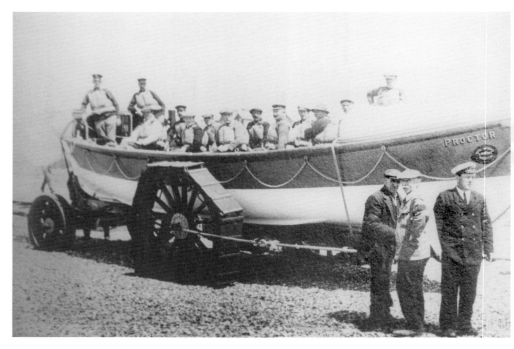

The *Proctor*, in around 1920, ready for launch.

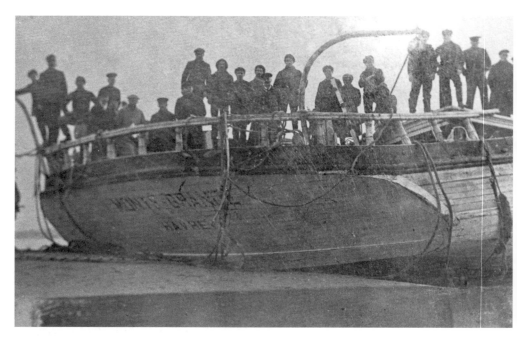

The French merchant vessel *Monte Grande*, registered in Le Havre, was wrecked in January 1920. On that occasion the lifeboat was launched by the nurses from 'Suntrap Home', and fifteen lives were saved.

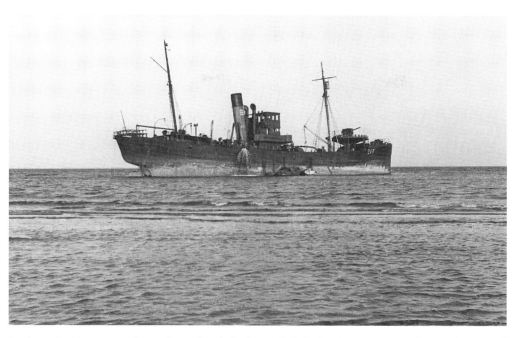

In about 1940, an armed merchant ship (which was holed after hitting a mine during the Second World War) ran aground off Eaststoke.

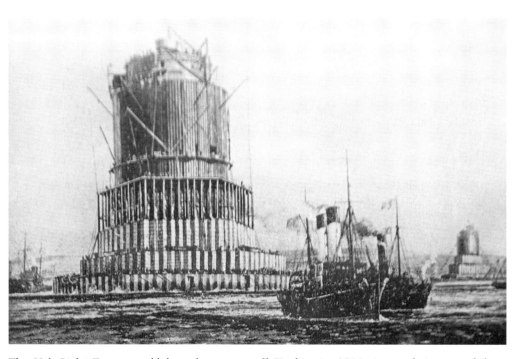

The Nab Light Tower would have been seen off Hayling in 1920; it was being towed from Shoreham to the Nab Rock to the east of the Isle of Wight to replace a lightship.

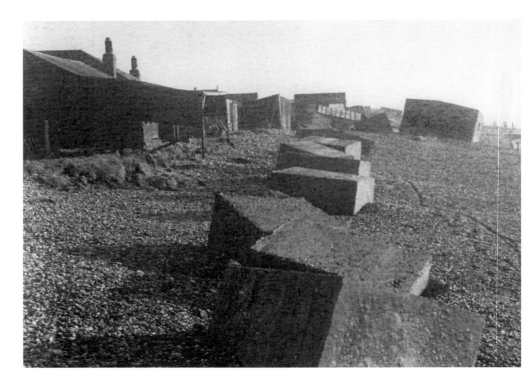

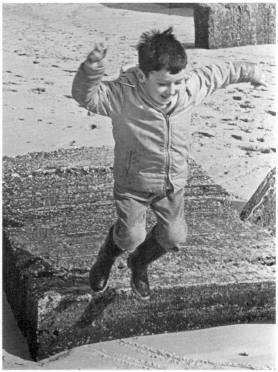

Above: The Second World War beach defences at Eaststoke. There was a further row of barbed wire nearer the shoreline.

Left: After the war, the former invasion defences made an excellent adventure playground, as demonstrated by the son of the author in 1965.

2

BEACHLANDS

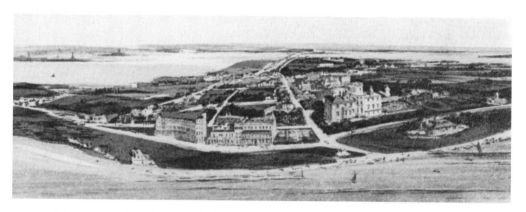

An artistic impression of Hayling Island, showing the grand buildings on the seafront in around 1900.

Beachlands crossroads in around 1910.

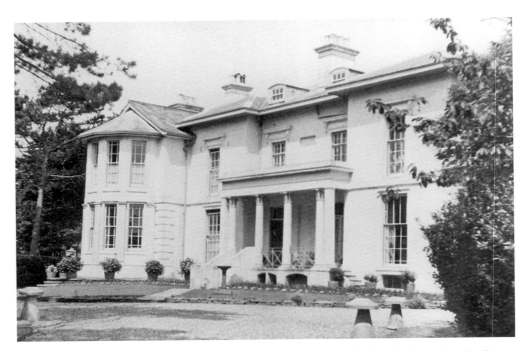

Richmond House *c.* 1935. Although this was a very elegant house believed to have been built as a private residence, there seems to be no record of who lived there. It is thought that it was later used as a private school.

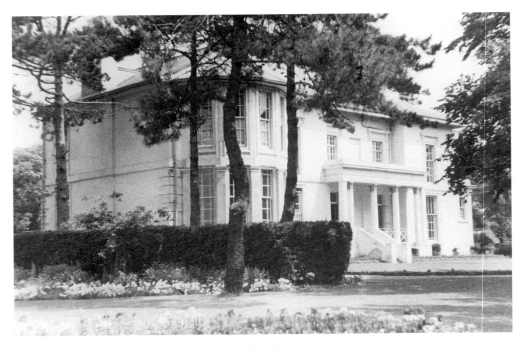

Another view of Richmond House from around 1935.

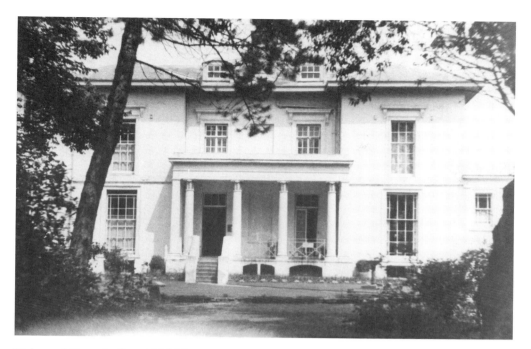

Richmond House in the mid-1930s.

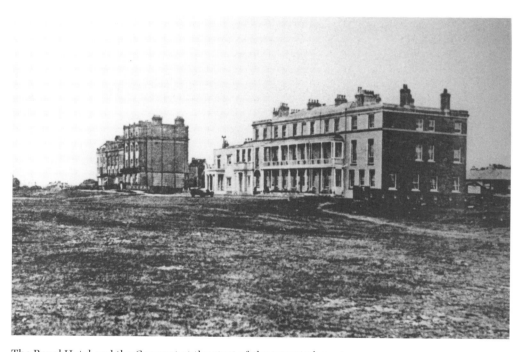

The Royal Hotel and the Crescent at the start of the twentieth century.

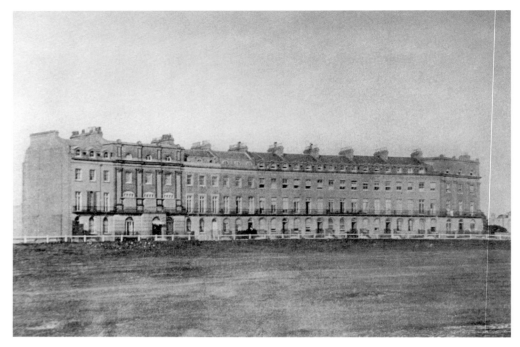

The foundation stone for Padwick Terrace (The Crescent) was laid in 1825 but only about two thirds of The Crescent was completed. The intention was that it would resemble the famous crescent in Bath, but it failed to be completed. This photograph was taken in around 1900.

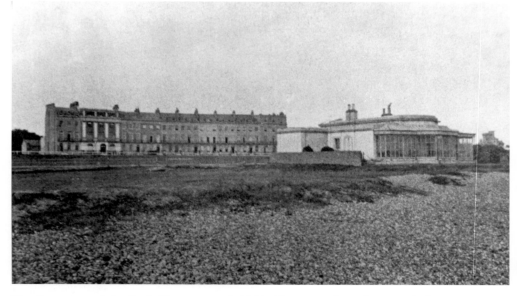

The Crescent and the Bath House around 1900. The original ten houses of The Crescent are vaguely delineated, with each having four stories. By the 1950s many of the houses had been converted into flats.

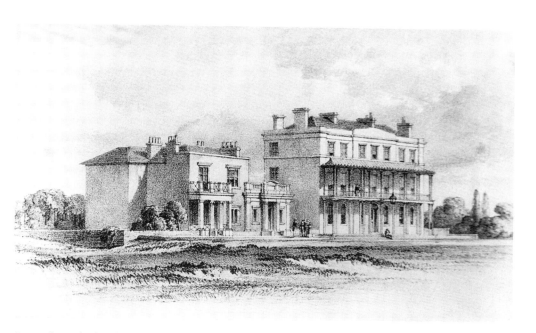

An architect's sketch of the proposed Royal Hotel in about 1820. The common in front of the hotel was used as a horse racecourse in 1868.

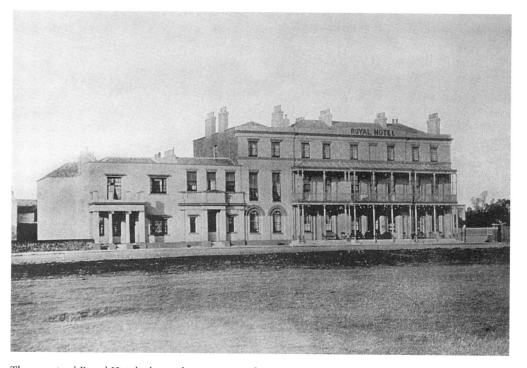

The eventual Royal Hotel, shown here in around 1900, had a few exterior changes over the years. The name was later changed to the Norfolk Hotel.

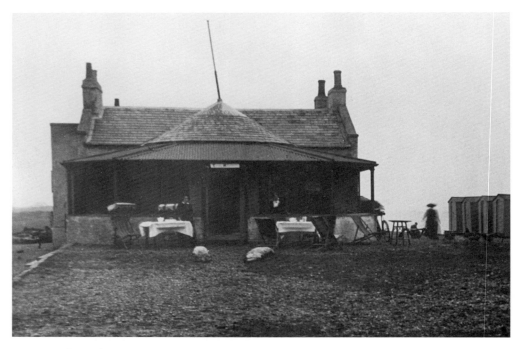

By 1920, the Bath House was no longer used for its original intended purpose and became a café.

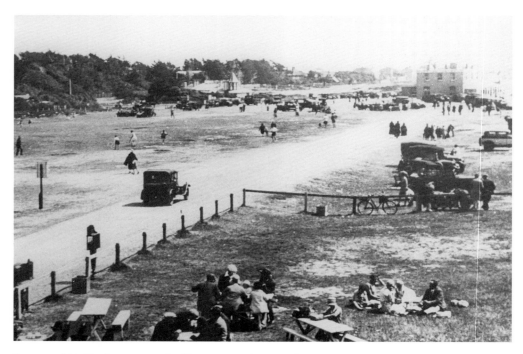

By around 1930, the common had become much more of a tourist attraction and facilities for picnics were provided.

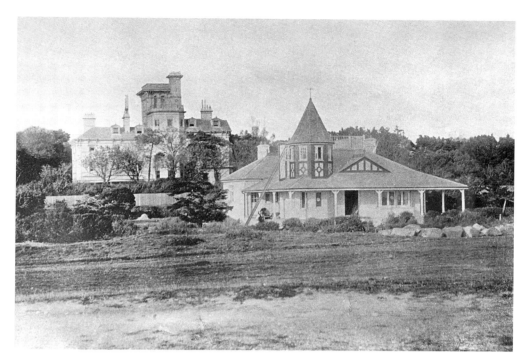

The Grand Hotel and Bungalow in about 1900. The delightful Bungalow was built around 1898 in the grounds of the hotel on land formerly known as the Grotto.

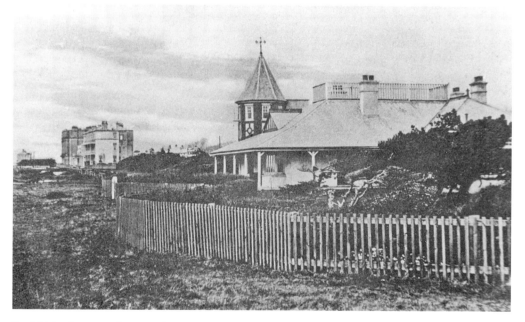

By 1911, the Bungalow was being used as a golf clubhouse. The Royal Hotel can be seen in the background.

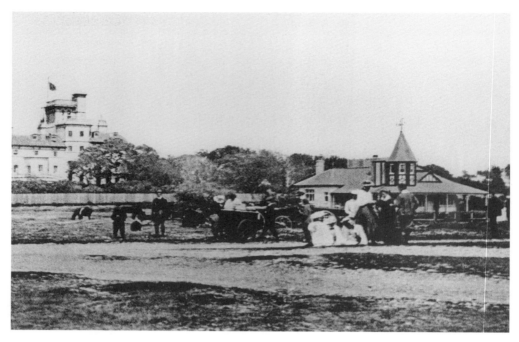

The Grand Hotel and the Bungalow in around 1904. Originally the Grand Hotel was Westfield House, built in 1862 in the style of an Italian villa for Col. G.G. Sandeman. In the 1890s, the house was sold to Mr Courtenay who converted it into the Grand Hotel.

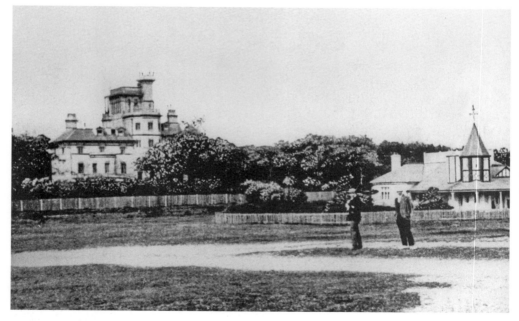

The golf club in about 1910. The club was later moved to Sinah where the new clubhouse was built as a faithful reproduction of the former Bungalow.

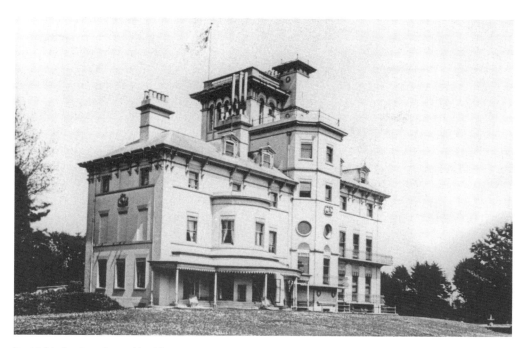

By 1929 the Grand Hotel had been converted into a private residence and renamed the Chateau Blanc.

A view looking east from the Grand Hotel in about 1900.

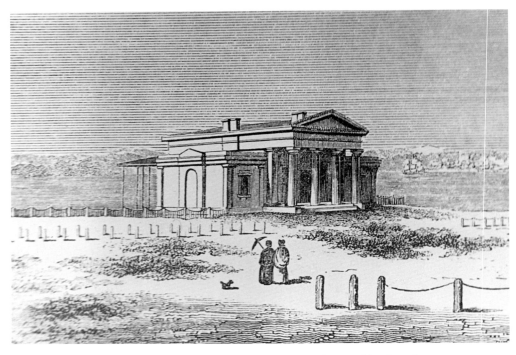

The intended library in the plans of 1850 eventually became the Beachlands Café.

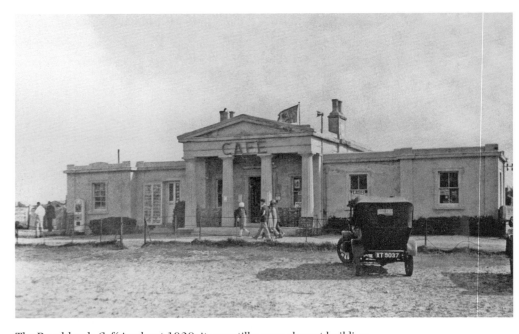

The Beachlands Café in about 1920; it was still a very elegant building.

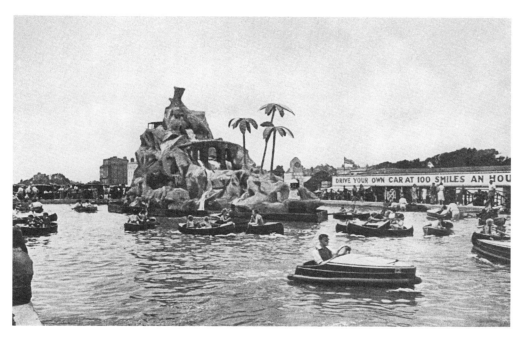

Around 1927 land previously the site of the Bungalow was purchased by Butlin's and became an amusement park, with attractions including a Monkey Island, a boating lake, and dodgem cars.

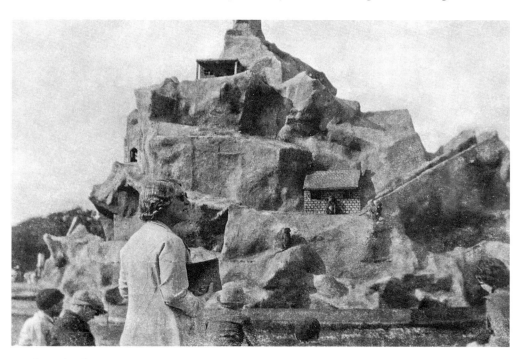

Monkey Island in 1938. Two monkeys can be seen, one in front of its house and the other lower down to the left.

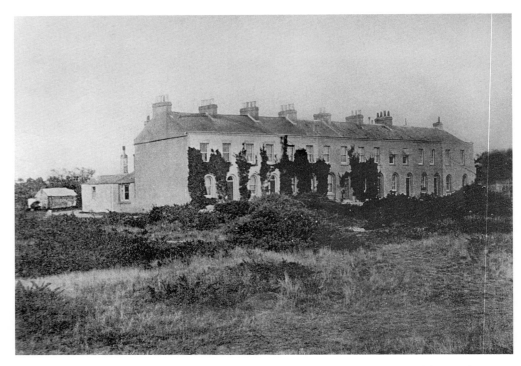

Seaview Terrace in about 1900, showing that some parts of the Common had been taken over by scrub. The original photograph was from the booklet 'Views of Hayling', so it is a reasonable assumption that efforts were being taken at that time to promote tourism.

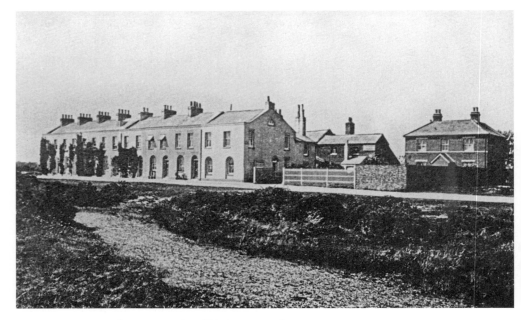

Seaview Terrace in about 1920; the old bakery is at the rear.

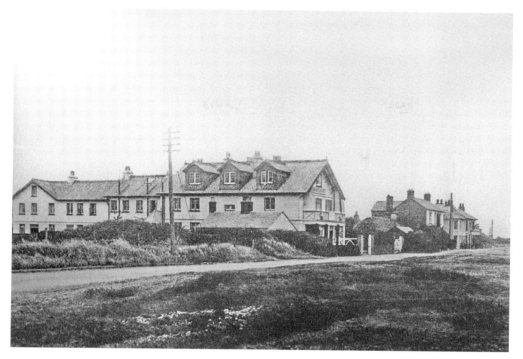

Suntrap School in about 1920. It was previously known as St Andrew's School.

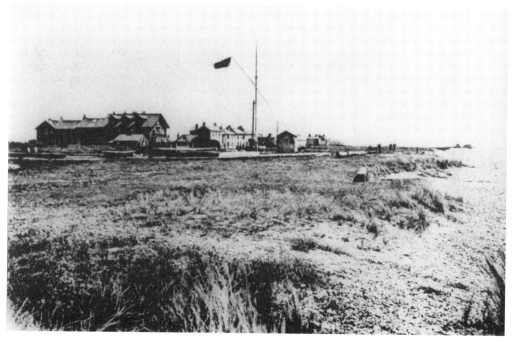

A view of East Hayling, originally used as a postcard in 1904.

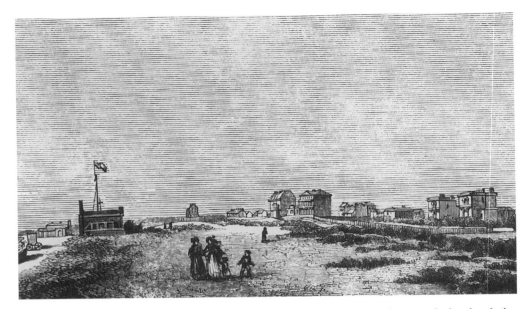

It is assumed that this engraving showing the Common was an architectural sketch of the proposed development of Hayling seafront in about 1830.

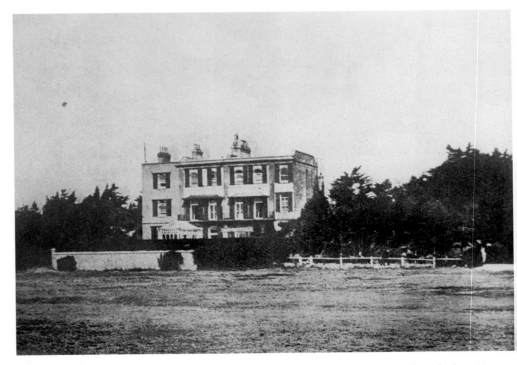

Seager House School, which took both boarding and day girls in 1930, 'occupied an ideal position on the seafront'. The principals were Miss D. and Miss E. May, and the school also accepted boys under twelve years of age.

3

EAST HAYLING

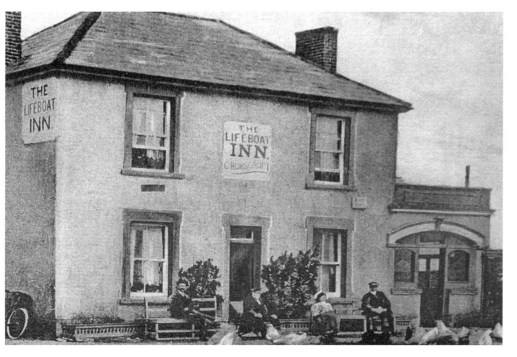

The Lifeboat Inn on the seafront, *c.* 1910. The inn was no doubt a welcoming sight to the lifeboat crews returning from a hazardous rescue.

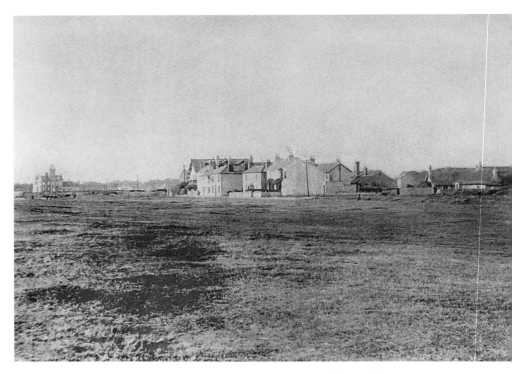

East Hayling in about 1900; Lama House can be seen in the background.

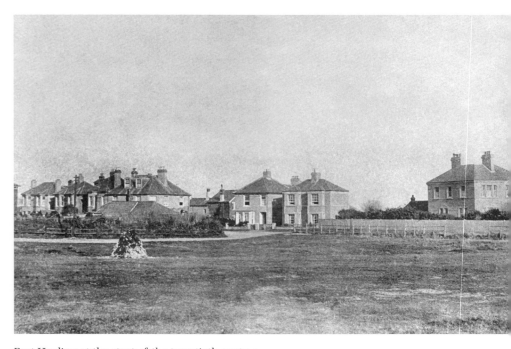

East Hayling at the start of the twentieth century.

East Hayling in about 1900. The presence of so few buildings makes the location of the site difficult to determine.

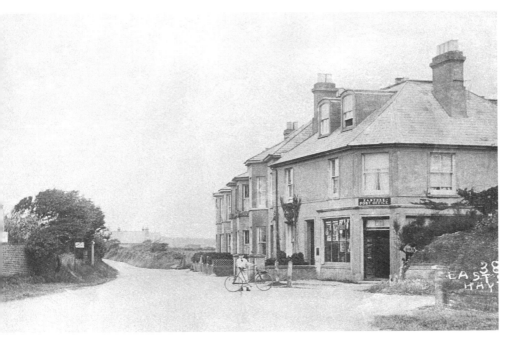

Eaststoke Corner and post office at the junction with Rails Lane in about 1910.

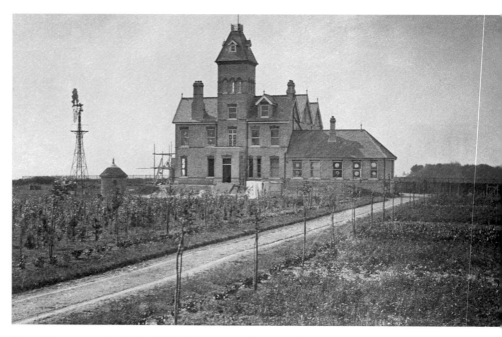

Lama House was built in 1899 for a Mr Johnson who had lived in Russia for many year
Here the house is seen nearing completion.

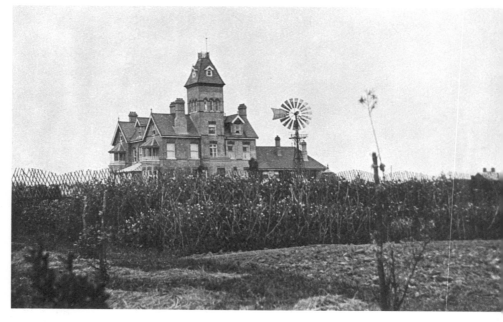

Lama House in about 1900. The house was later bought by a syndicate who for some unknow
reason pulled it down while it was still in good repair.

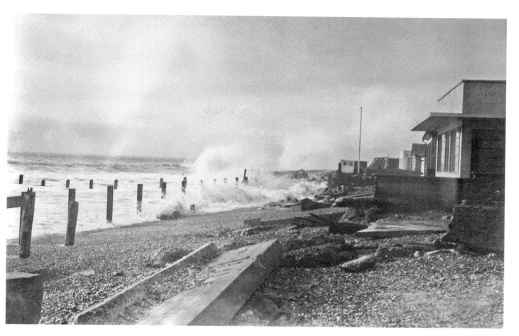

Waves crashing over Eaststoke in about 1935, before the sea wall was built.

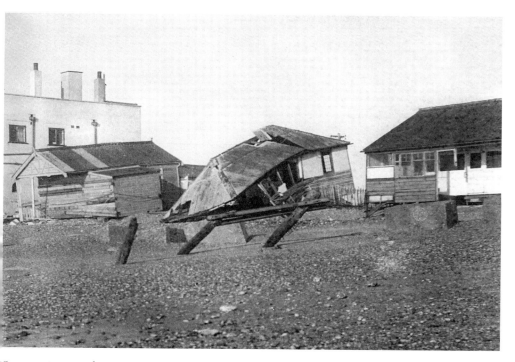

On occasions, such as sometime around 1935, the sea took its toll on the chalet bungalows built along the seafront.

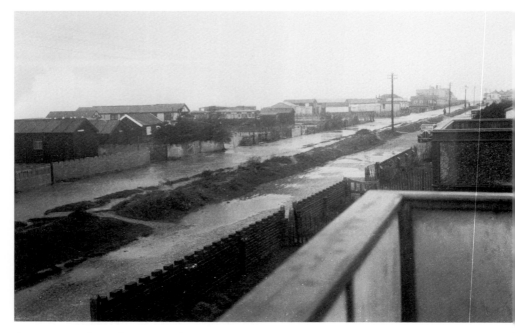

An annoying hazard at Eaststoke was flooding – which regularly occurred. This is Southwood Road in about 1935.

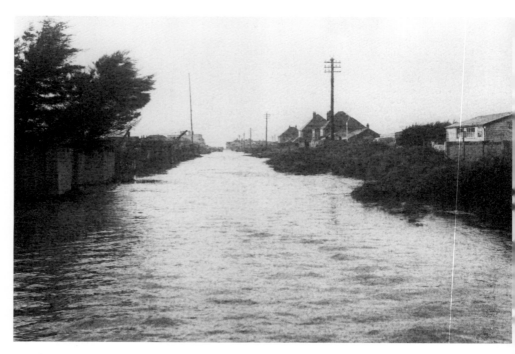

Another view of the Southwood Road floods in about 1935; in this photograph the water appears to be much deeper.

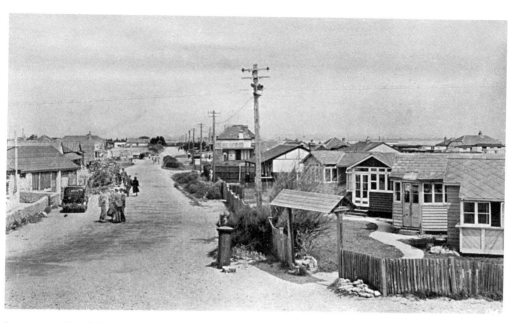

In summer, the chalets of Southwood Road became a much more attractive proposition.

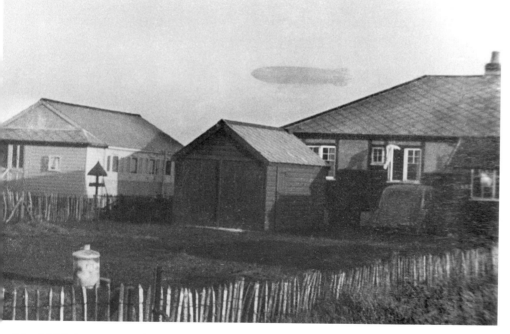

n May 1939, just prior to the outbreak of war, a German Zeppelin flew over the South Coast of England to gain intelligence on the British radar capability. It is has since been learnt that the radar detection equipment in the Zeppelin was not functioning, and consequently the mission was a failure.

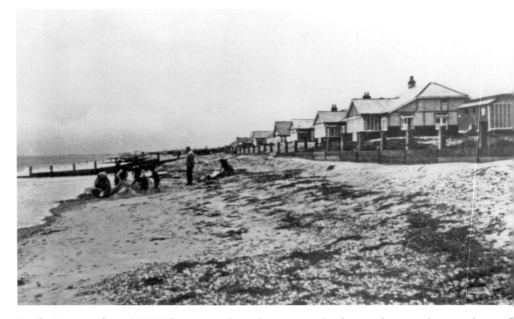

Sandy Point in about 1924. The group of people appear to be digging for something in the sand but they do not seem appropriately dressed for building sandcastles.

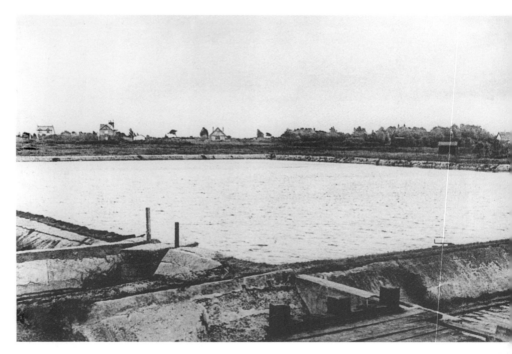

Canoe Lake at the salterns in about 1935. The lake appears to be well-preserved despite not being used for sea-salt extraction for many years. The salterns became so dilapidated by around 1877 that they could no longer be used to extract salt.

4

MENGHAM

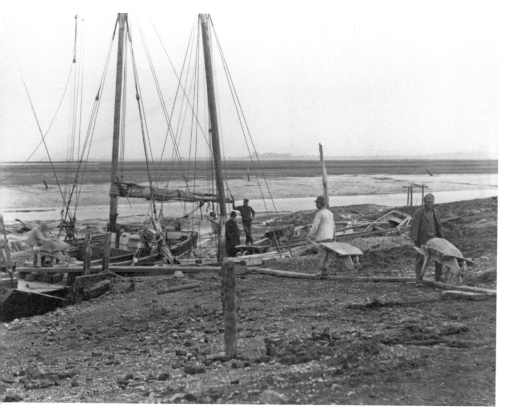

Unloading grain from a sailing barge at Salterns Quay at low tide in about 1900. This photograph was printed from an original photographic plate taken by Mr H.R. Trigg.

In about 1928, Mengham Farmhouse was occupied by the Bowers family.

By about 1965, Mengham Farmhouse had been proudly restored by the then owners, Jack and Norma Smith. The end wall of the Regal Cinema can be seen on the left.

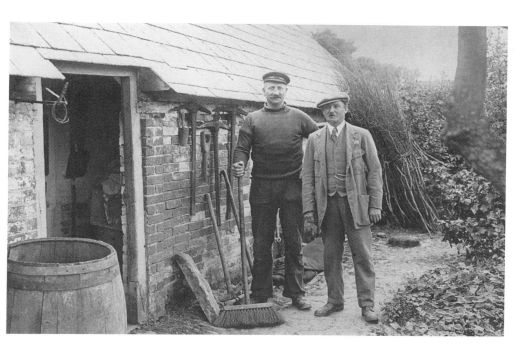

Two members of the Bowers family standing at the back door of Mengham Farmhouse in 1918.

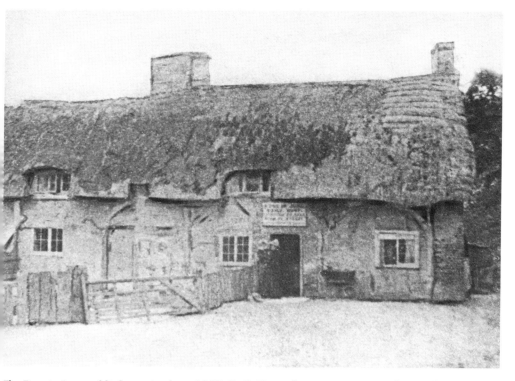

The Rose in June public house in about 1885. Emily Hunt, the proprietor, is standing in the doorway.

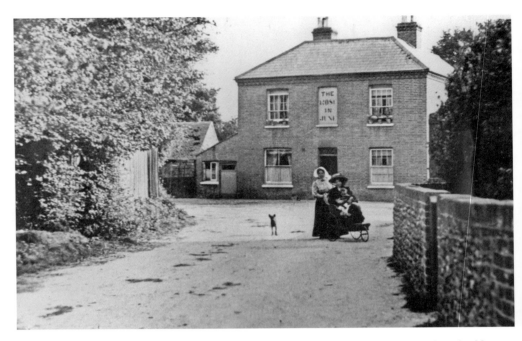

The thatch-roofed Rose in June was destroyed by fire and replaced with this modern building in about 1910.

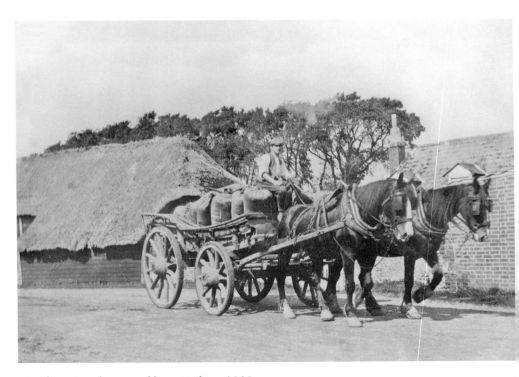

Mengham Farmhouse and barn in about 1920.

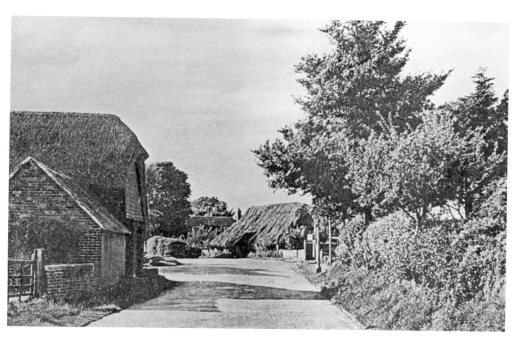

A corner of Old Mengham in about 1920.

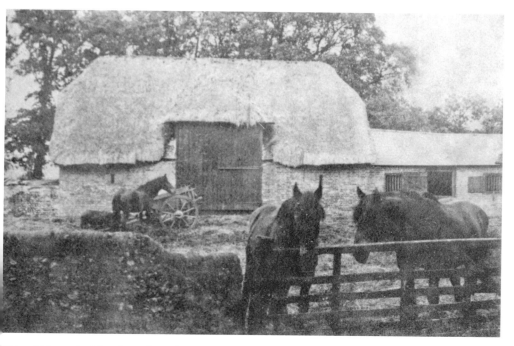

This old barn in Mengham later became the site of the Regal Cinema. The advent of television saw customer levels drop and the cinema went into decay; it was subsequently demolished to make way for a supermarket.

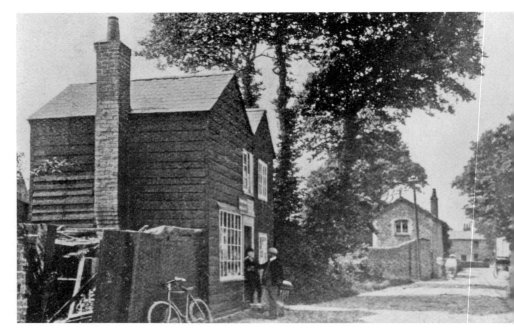

The Black Hut, Mengham Road, seen here in about 1920, was purportedly built with timbers salvaged from a wreck.

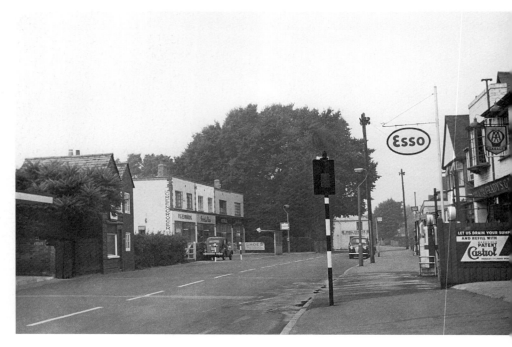

By 1967 the Black Hut still existed but the remainder of Mengham Road had changed considerably and even greater changes have occurred in the last forty-five years.

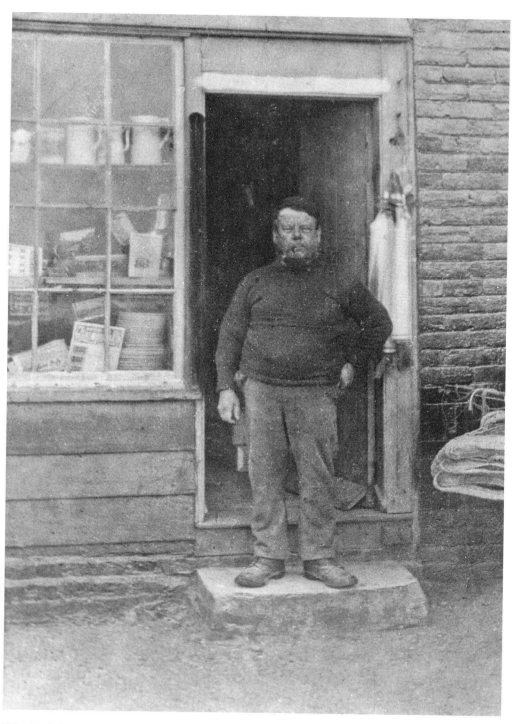

Toby Lock kept a general store at the Black Hut. This photograph probably dates back to about 1920. Toby was a great favourite with the local children as he frequently gave them free sweets.

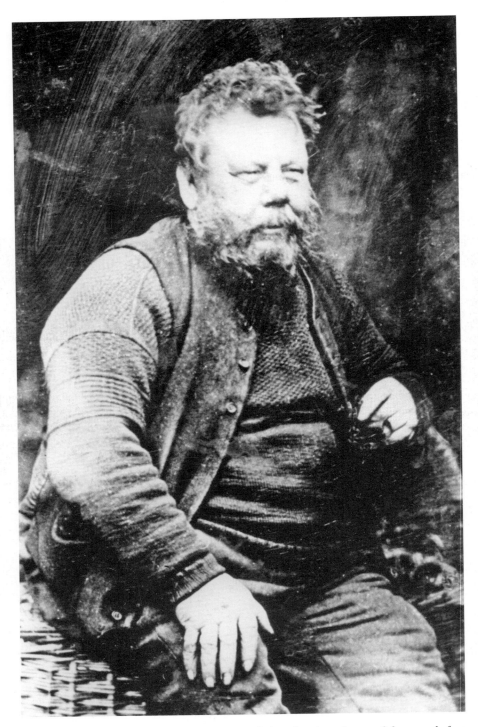

Toby was a larger-than-life character and was believed to have been a fisherman before becoming the general storekeeper.

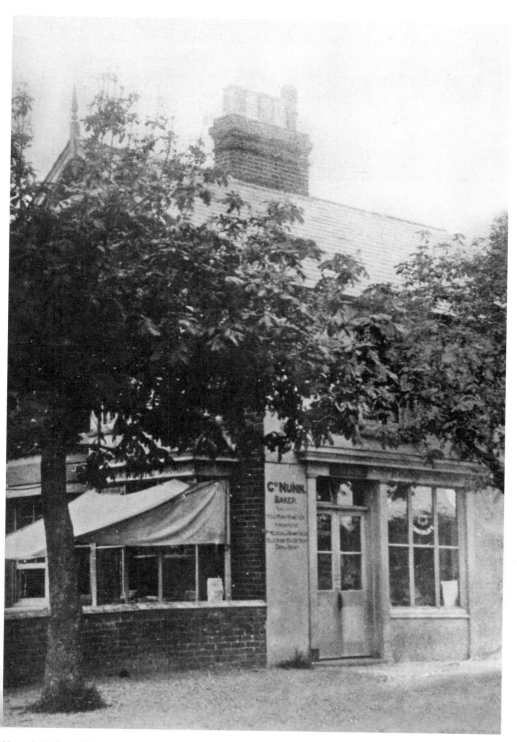

Nunn's Bakery. There is no record of the date this image was taken.

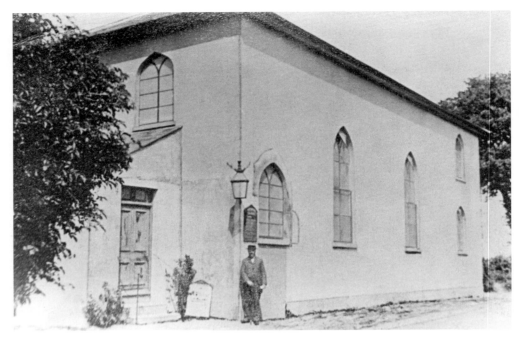

The old Congregation Church in Hollow Lane. The pastor is standing near the doorway.

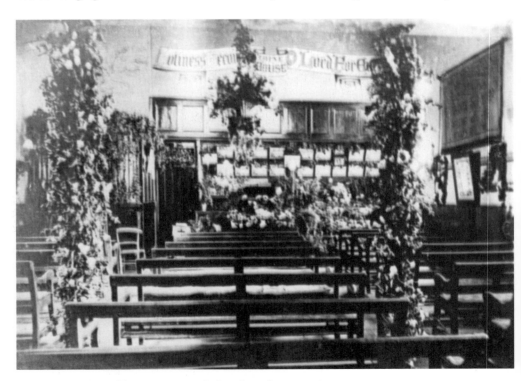

The interior of the old Congregational Church in about 1880.

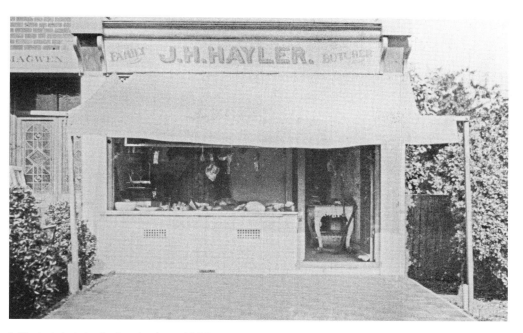

J. Hayler's butcher's shop in about 1920.

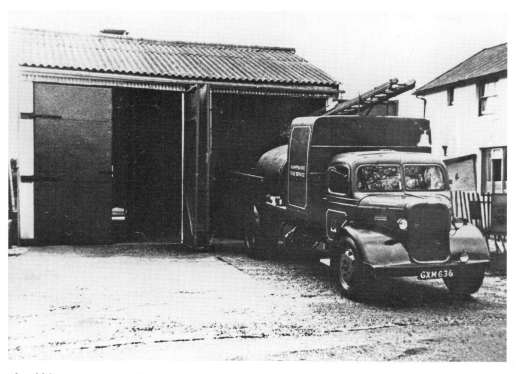

The old fire station in 1959. It was situated next to the Regal Garage in Hollow Lane, near the corner with Elm Grove and Seagrove Avenue. (Reproduced with the kind permission of M.J. Rolfe)

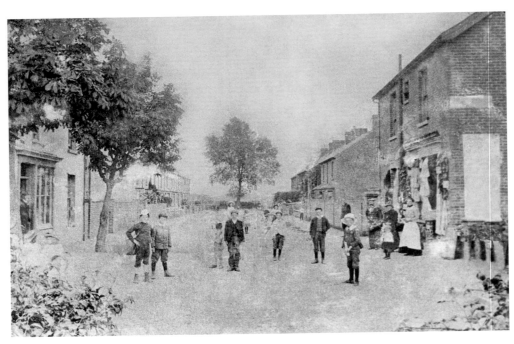

Palmerston Road appears in to have been very busy in 1905.

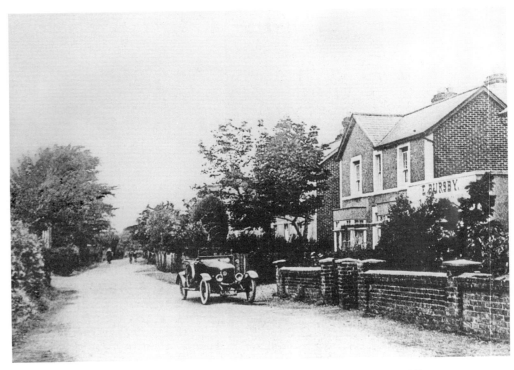

E. Bursby's shop (situated in either Elm Grove or Palmerston Road) in about 1925.

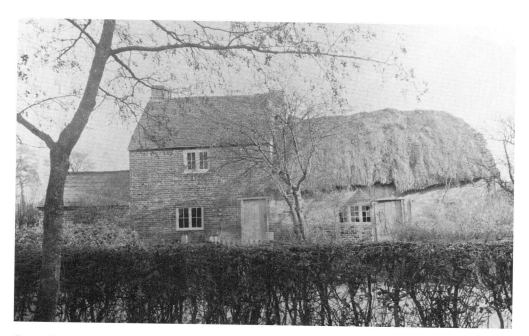

Stares Farm in Elm Grove in about 1905. It was turned into two cottages in 1908 before being pulled down in about 1920. There is no indication of the exact location of the farm.

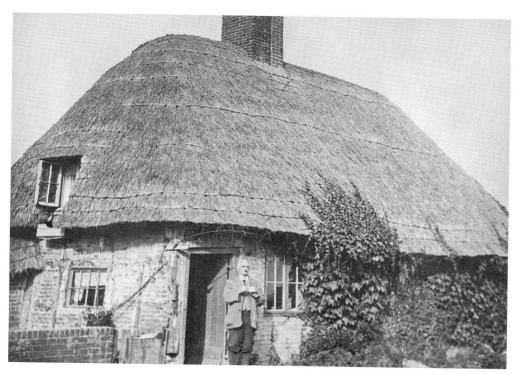

Another property of unknown date in Elm Grove.

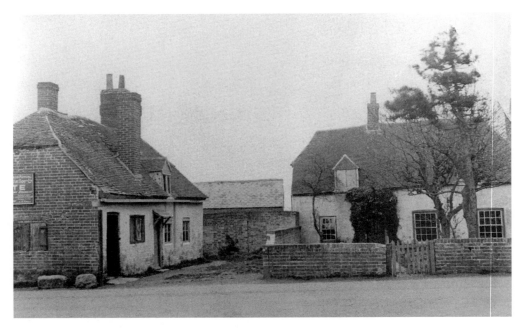

This site at Gable Head became the Co-op store in about 1920. The building on the left has a sign on the wall indicating that it was owned by the Co-op at the time the photograph was taken.

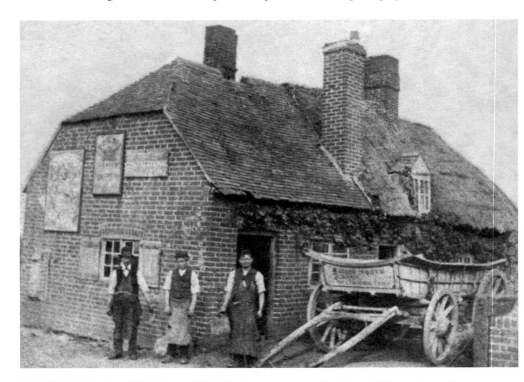

In 1900, the blacksmith's shop at Gable Head was opposite the Co-op in Tournerbury Lane.

The old forge in Tournerbury Lane just before it was demolished in about 1965.

The remains of the stocks used for shoeing horses at the derelict forge in the 1960s.

Building works in progress at the Gable Head crossroads in about 1965.

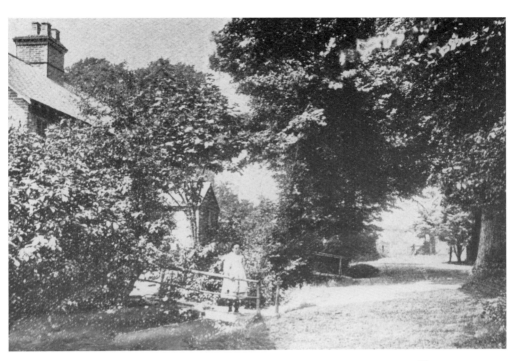

Tournerbury Lane about 1907, in the grand old days before roads were dominated by cars!

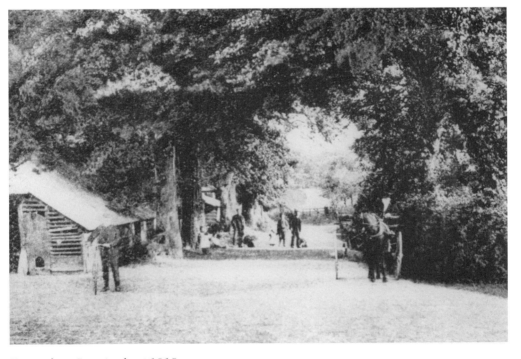

Tournerbury Lane in about 1910.

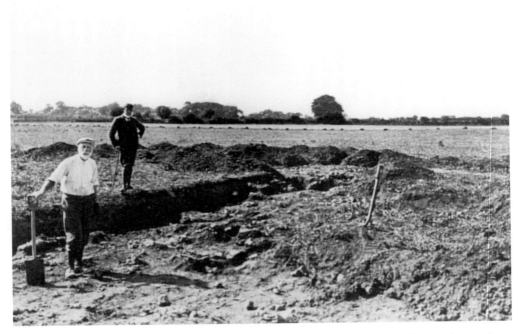

Excavations of the Roman villa at Tournerbury in 1901 by Mr T. Ely. He worked on the site from 1898 to 1918.

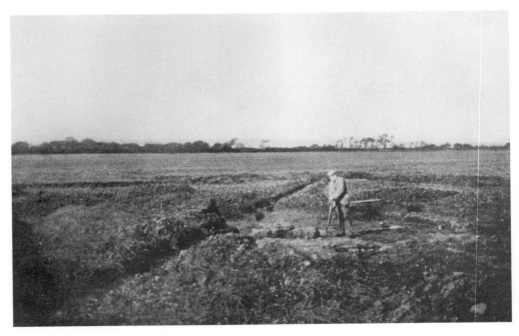

Excavations in 1903 of the Roman central circle. The original photograph was taken by Col. Sandeman.

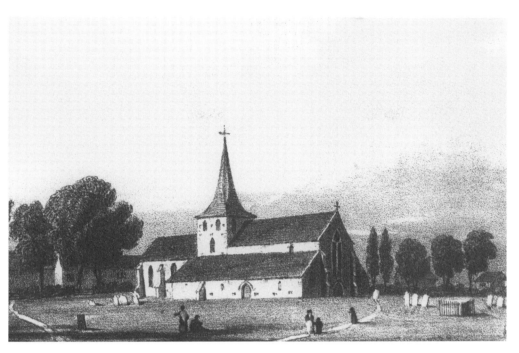

A sketch of St Mary's Church around 1820, copied from a *Topographical Account of Hayling Island* published in 1826.

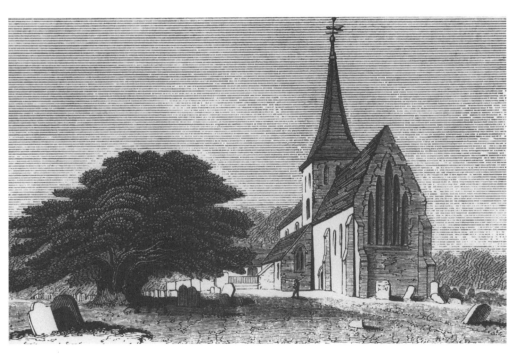

An engraving of St Mary's Church showing the magnificent old yew tree in the 1830s.

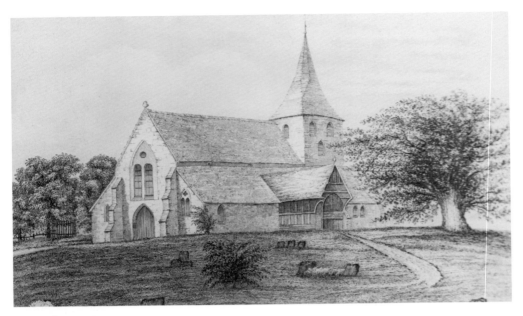

A sketch of St Mary's Church around 1850.

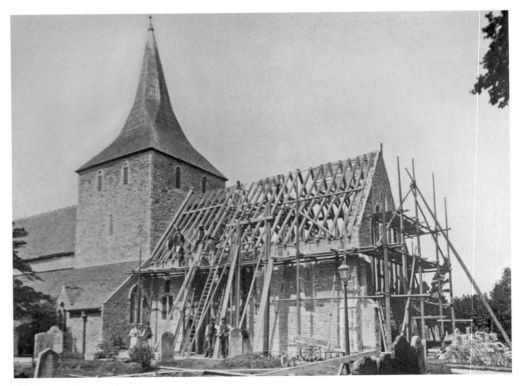

The re-roofing of the church in 1893. The steeple had been struck by lightning in July 1872, there being no lightning conductor at that time. Fortunately the damage was not significant.

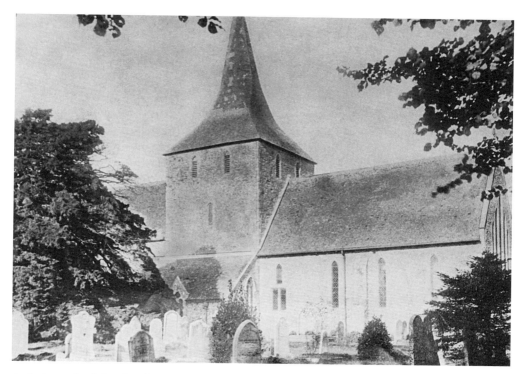

A photograph of the church in 1905.

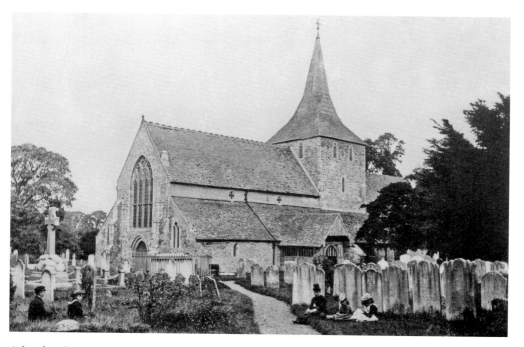

A family takes a rest in the church graveyard at the turn of the twentieth century.

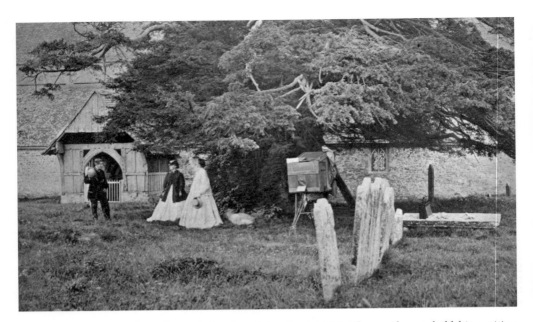

Posing for a photograph in front of the church in about 1900. The gentleman held his position during the long exposure time required when taking a photograph in those days, but unfortunately the two ladies moved their heads, resulting in indistinct images of their faces. Note the dark box mounted on a tripod used by the photographer to change his photographic plates.

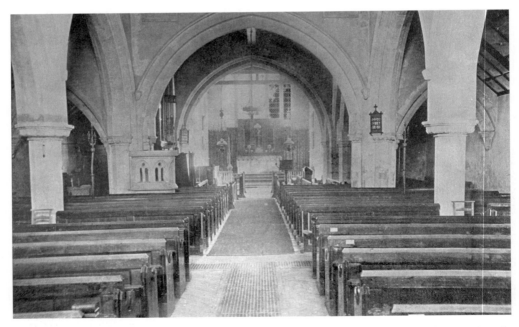

The interior of St Mary's Church in about 1900. Until 1873 there was no lighting in the church, and on winter evenings it was expected that the congregation would provide their own candles. In 1873 oil lamps were fitted and then, in 1882, these were replaced with gas lamps.

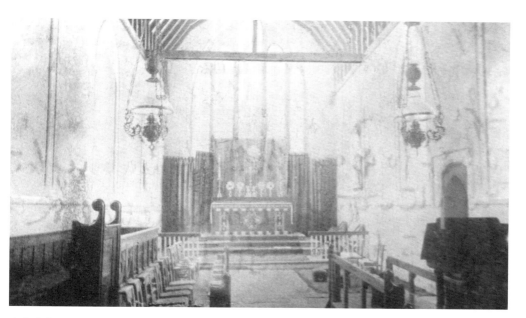

A slightly earlier image of the St Mary's Church interior; this was taken in about 1895.

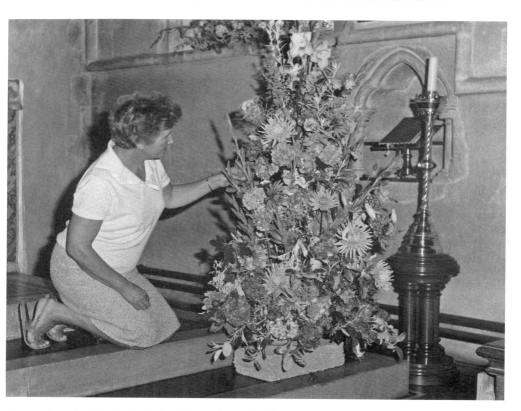

Preparation of a floral exhibit for a flower festival held in the church in the 1960s.

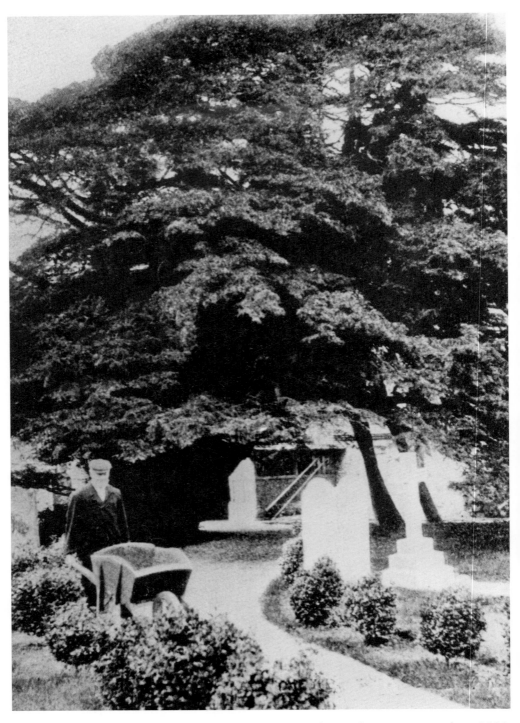

Mr Thomas Bowers, the sextant, working in the graveyard near the yew tree, in about 1904. The oldest known headstone is dated 1719.

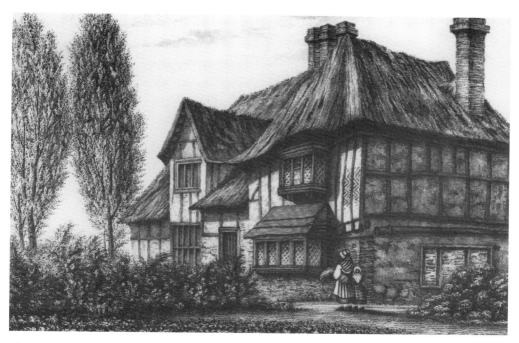

The Old Vicarage House, believed to have been in Tournerbury Lane, seen here in the 1820s. Others claimed that it was situated in Vicarage Field, 300 yards south of the church.

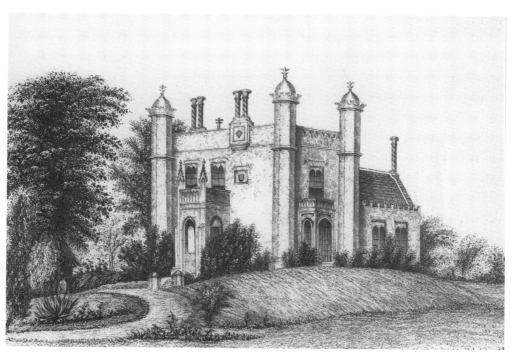

The new Vicarage House in the 1840s. It was built in 1832 and later became known as St Christopher's.

A view of Church Road in the 1930s. The telegraph poles were put up in 1872.

Mengham Road, now Hollow Lane, around 1900.

The Pound, shown here in about 1910, was a brick or stone compound in which stray animals were placed pending being reclaimed by their rightful owner.

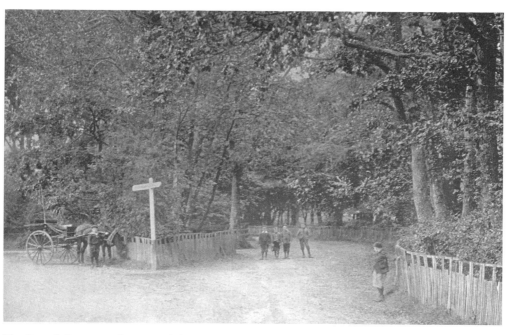

The Pound Corner at the turn of the twentieth century. Perhaps the boys were making their way to the school.

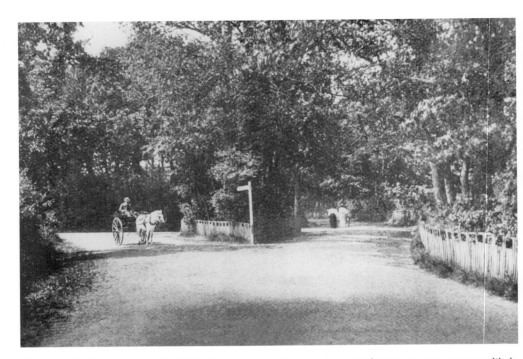

The Pound Corner in about 1905. The pony and trap look very elegant, so it was most likely owned by one of the few rich residents living at Hayling. The road surface looks to be in very good order unlike most roads at that time.

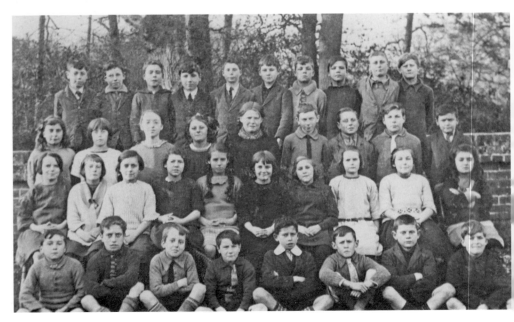

The class of 1926 at Hayling School on School Corner. This appears to be the complete junior school. Unfortunately, this photographic collection does not hold a copyright-free image of the school.

5

WEST TOWN AND
MANOR ROAD

A sketch reproduced as a postcard of Ham Corner in about 1937, at the corner of Beach Road and Station Road. It later became known as Bank Corner.

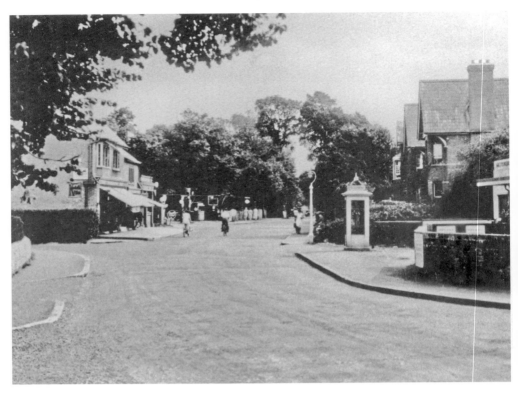

Beach Road, 1939, with one of the few white – rather than a conventional red – public telephone boxes.

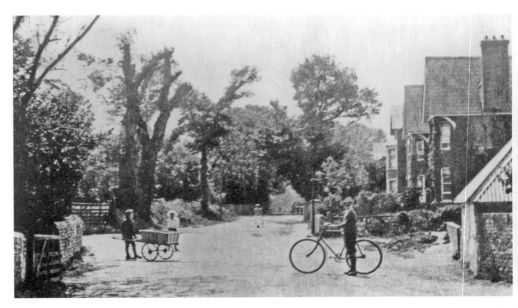

Beach Road in the 1920s. The boy with the basket trolley is possibly making house deliveries for one of the local stores, as was the practise in those days.

Westfield Road in about 1900. It later became known as Beach Road.

Westfield Road at the turn of the twentieth century. There appears to be some gas street lighting by that time.

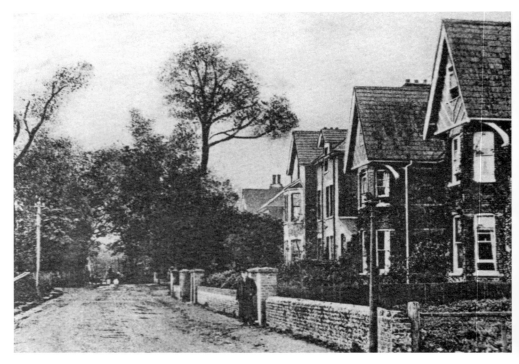

Westfield Terrace on Westfield Road in about 1910.

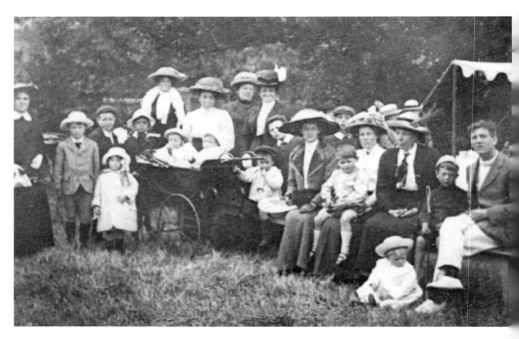

Hayling Flower Show, 1913. This photograph was loaned by Mr Pope, who is the small boy sixth from the right.

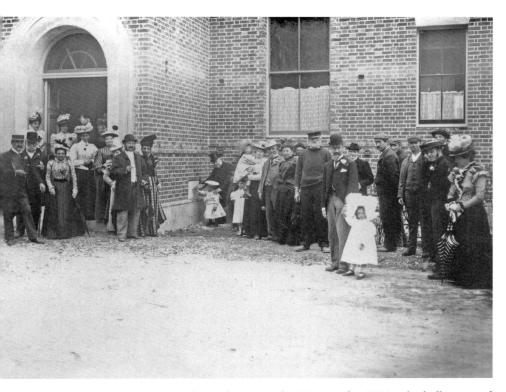

he opening of the Victoria Hall, Beach Road, on 25 July 1898. In the 1920s, the hall was used
) project silent films, until the new picture house on St Mary's Road was established.

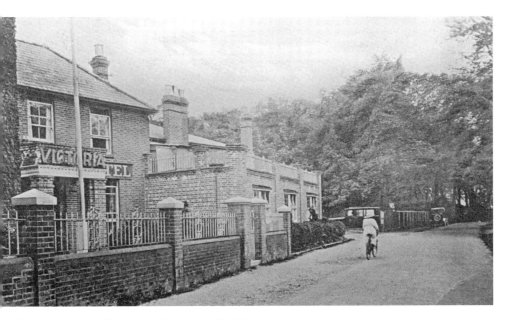

'he Victoria Hotel on Beach Road in the mid-1920s.

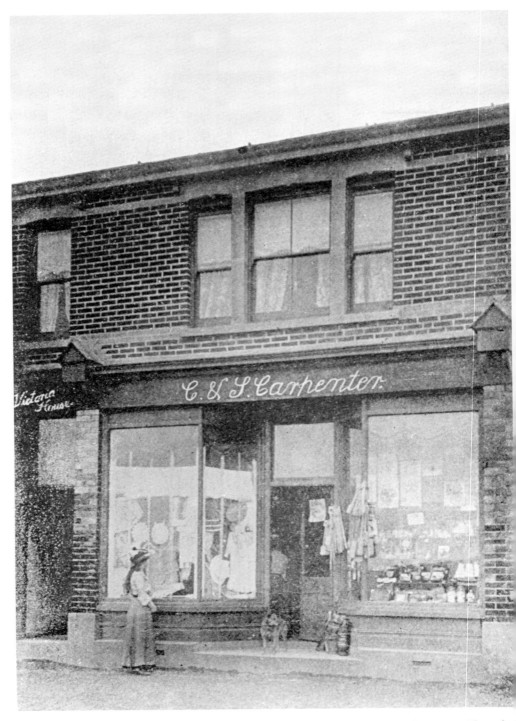

C. & S. carpenter's shop sold fancy goods and stores at the start of the twentieth century. They also published a booklet, 'Views of Hayling' – many of their photographs are reproduced in this collection.

The south end of Beach Road around 1900.

Beach Road in the 1920s. The bus provided a regular service to and from Havant.

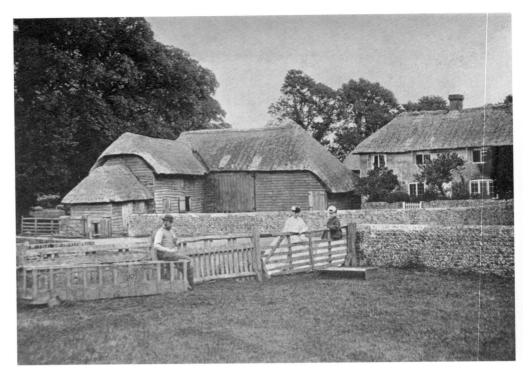

Myrtle Cottage, later named Deep Thatch, in about 1860.

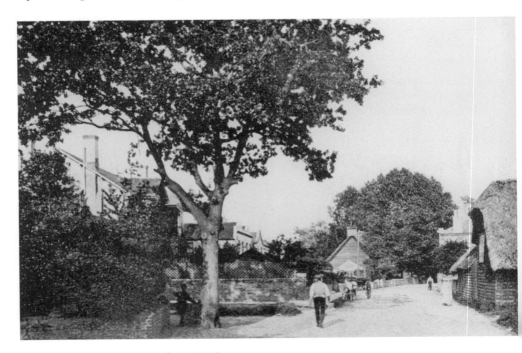

Station Road, West Town in about 1905.

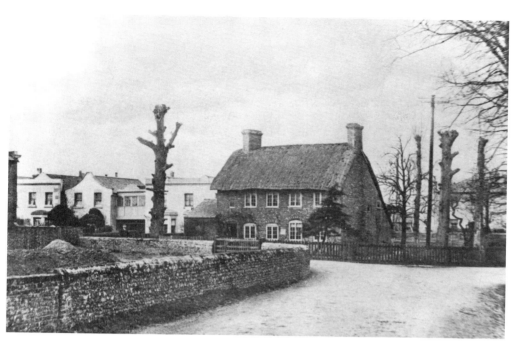

West Town Corner with West Lane around 1910.

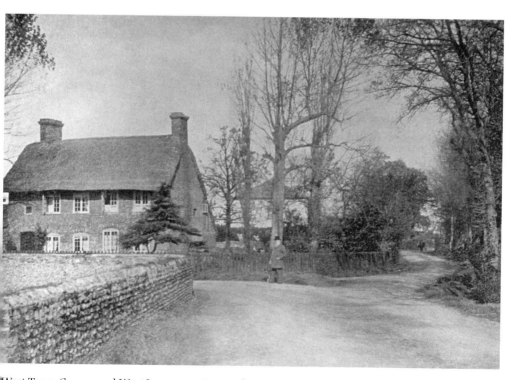

West Town Corner and West Lane sometime in the 1910s.

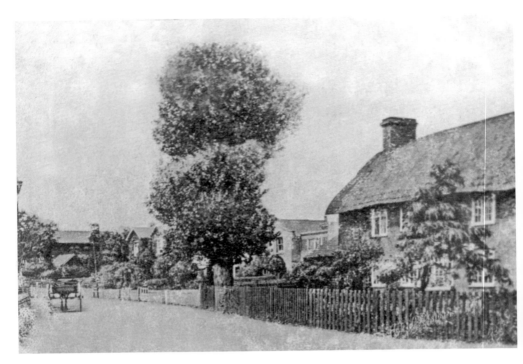

Station Road in about 1900.

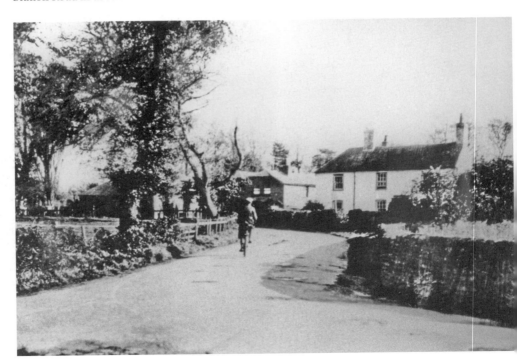

Station Road at the turn of the twentieth century.

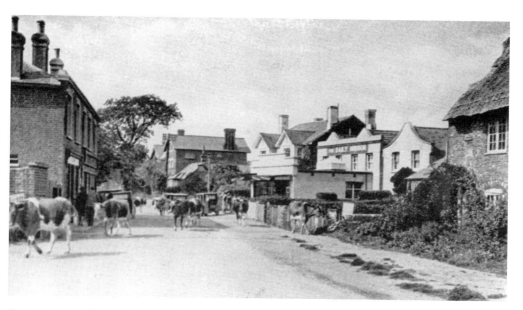

Station Road with a herd of cows being driven through the village in about 1930.

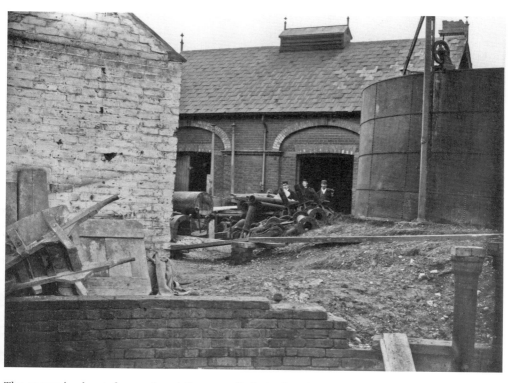

The gasworks, located near the station, supplied piped coal gas to houses for heat, cooking and light. The works were opened in August 1877 to extract the inflammable gas from coal. The large cylinder on the right was the gasholder used to store the gas under pressure.

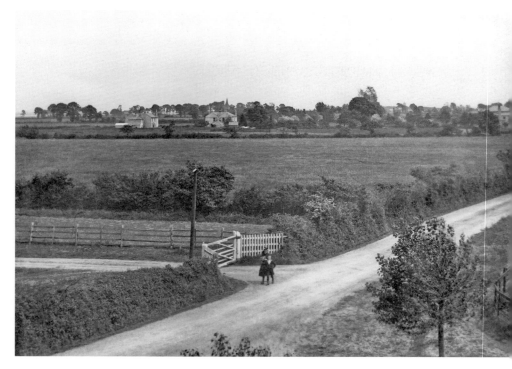

Station Road near the corner with Staunton Avenue in about 1900. Note the white-gated entrance to the railway station.

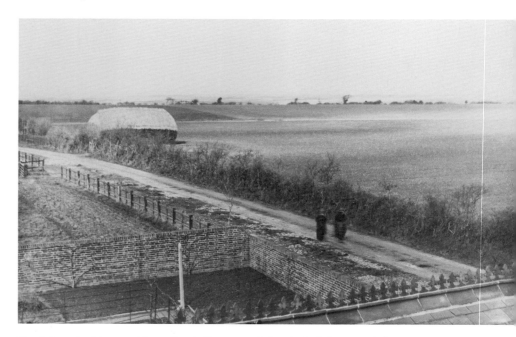

Sinah Lane looking west from the station around the start of the twentieth century.

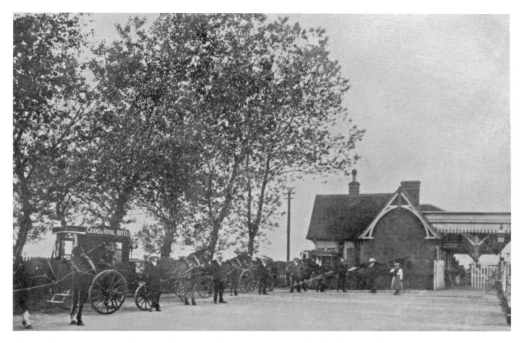

The railway station, shown here in about 1905, with the horse-drawn carriages awaiting passengers to take them to the hotels.

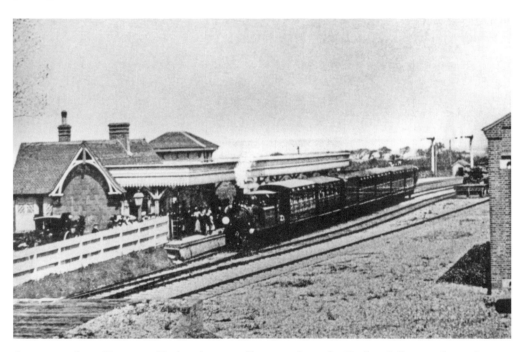

A train ran from Havant to Hayling known affectionately as the *Hayling Billy*; it is shown here in about 1902. The line was a single track and opened on 8 July 1867.

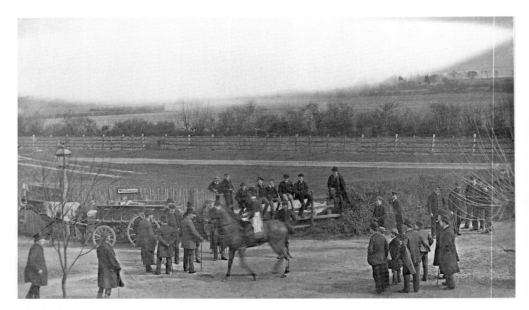

The Hampshire Regiment held its summer training camp several times at Hayling. Here the locals, photographed in about 1900, await the arrival of the soldiers off the train.

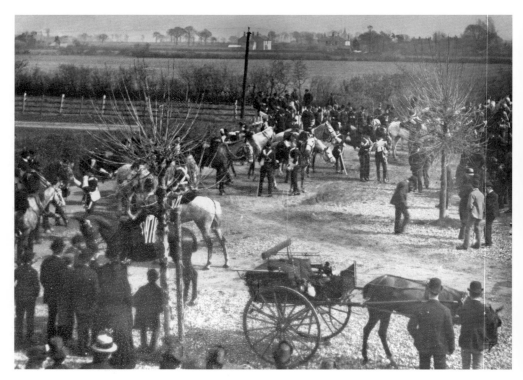

The horse-mounted soldiers of the Hampshire Regiment assembled in station approach in around 1900.

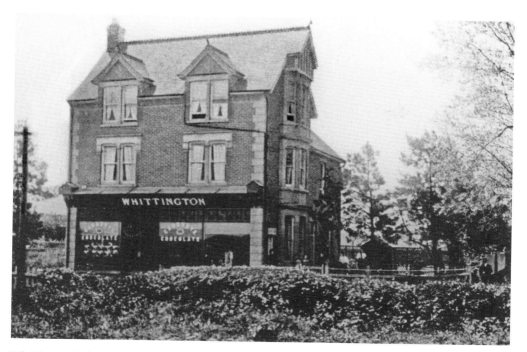

Whittington's shop on the corner of Station Road and Staunton Avenue in about 1904.

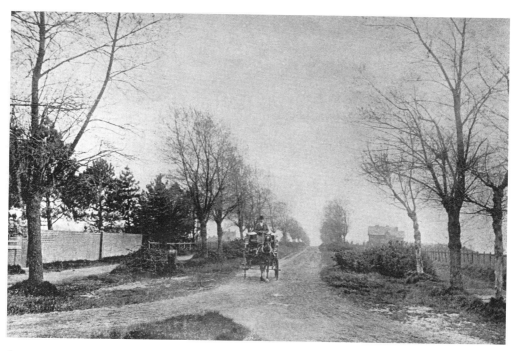

Staunton Avenue in about 1900; a horse-drawn carriage meanders along, probably making its way to the railway station to pick up passengers.

The junction of Sinah Lane and Park Lane at the turn of the twentieth century.

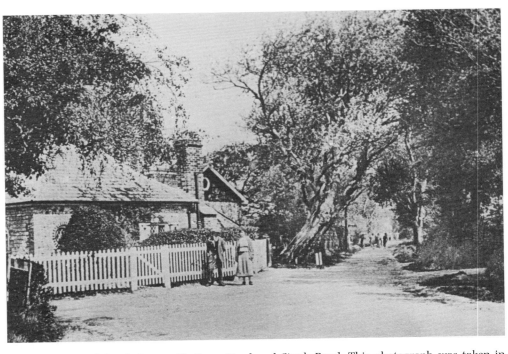

The T-junction of Sinah Lane with Ferry Road and Sinah Road. This photograph was taken in about 1900.

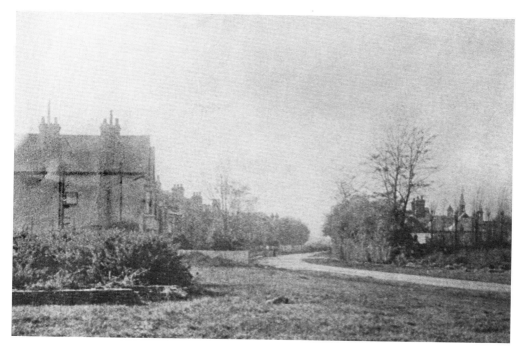

Park Road sometime around 1900.

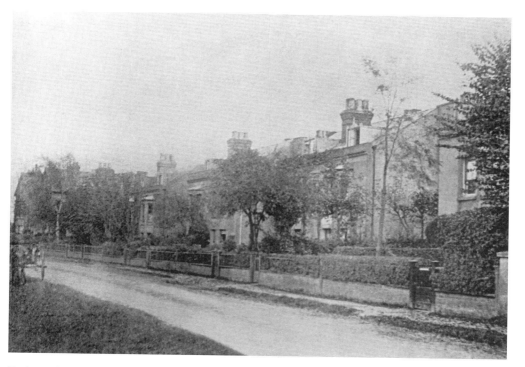

Park Road Terrace in about 1900.

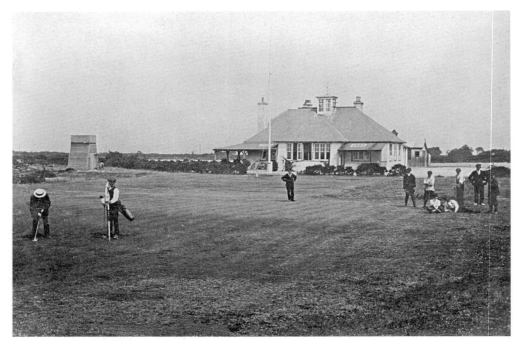

The golf club on Sinah Common in the 1930s. It was built to resemble the old clubhouse, formerly the Bungalow, at Beachlands near the Grand Hotel.

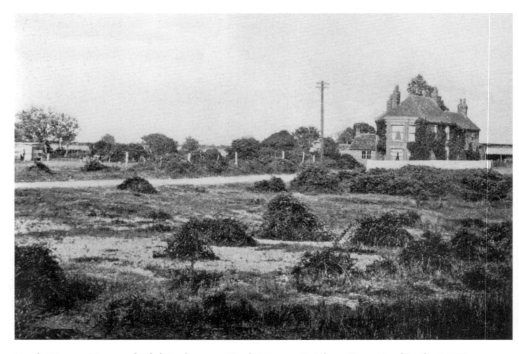

Sinah Warren House, which later became Sinah Warren Hotel, on Ferry Road in the 1930s.

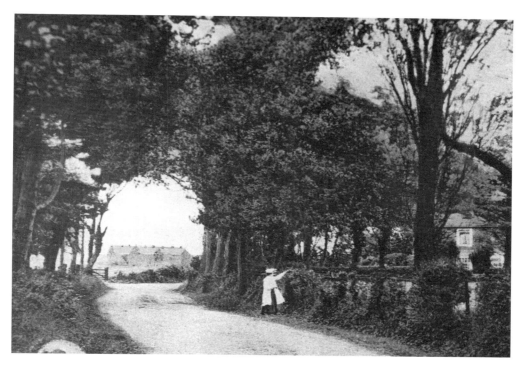

New Town Lane in about 1900.

Manor Road in the 1930s.

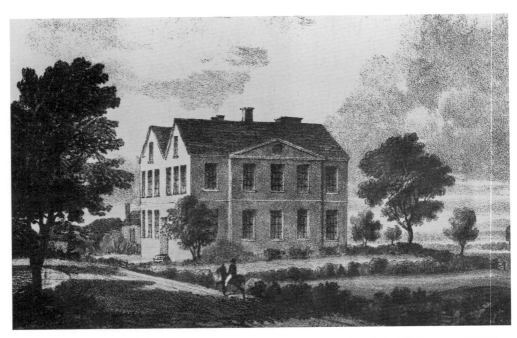

A sketch of the Manor House in about 1820. It was built for the Duke of Norfolk in around 1777.

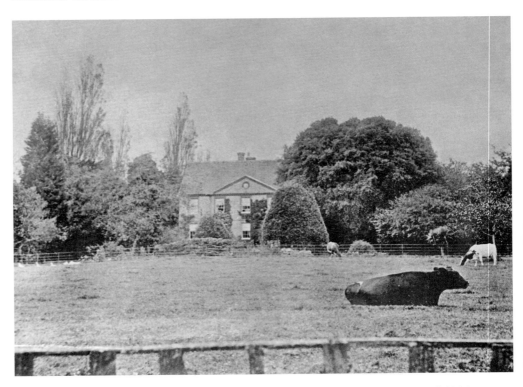

The Manor House looking slightly less majestic shown in a photograph taken around 1900.

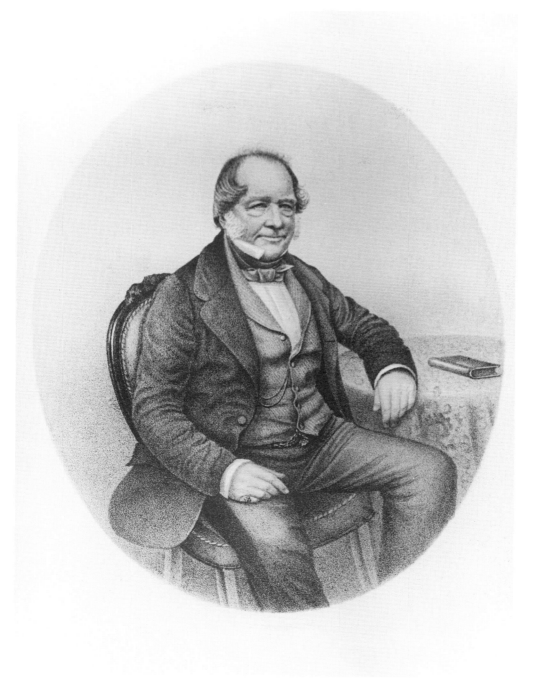

William Padwick Esq. in about 1850. Mr Padwick, who had grand designs for the development of Hayling, bought most of the island from the Duke of Norfolk in 1825 for £38,614 5s 5d. Between 1840 and 1850 he was in repeated legal proceedings to establish his rights as the Lord of the Manor. He died on 10 September 1861, after which the land was divided up and sold separately.

Manor Corner in about 1910.

Manor Road at the turn of the twentieth century.

6

STOKE

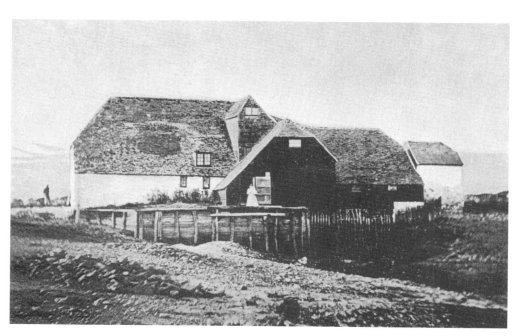

The Hayling tidal water mill was totally destroyed by fire on 5 January 1877, having only been restored by Mr Padwick in 1876. This image was a print from a very early half-tone printing block kindly loaned by Mrs Trigg, and printed by Mr E.H. Gridley. It is probably the only existing photograph of the mill.

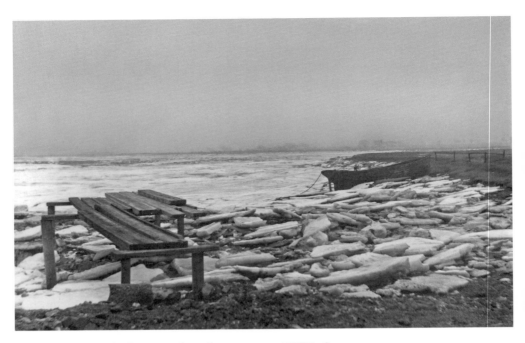

In January 1895, Chichester Harbour froze as seen at Mill Rythe.

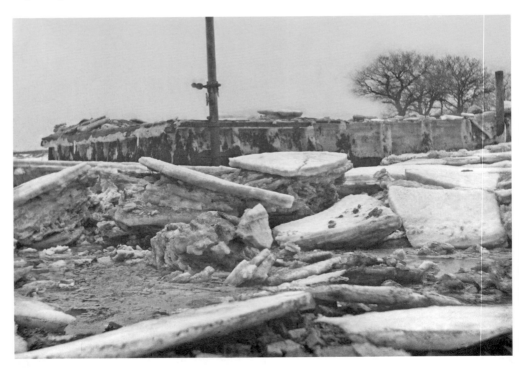

Another view of the sea ice in 1895, which was several inches thick. Langston and Chichester Harbours freezing over was a very rare occurrence.

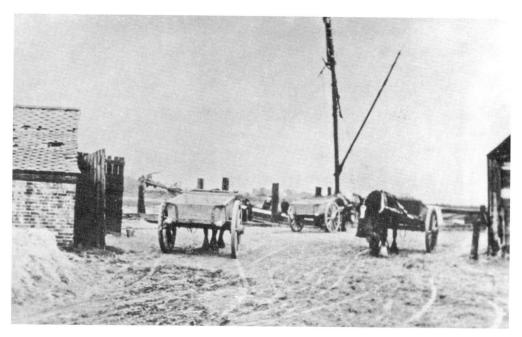

Judging by the number of horses and carts at Mill Rythe in about 1910, the quay must have been extensively used to import and export goods to and from the island by sea.

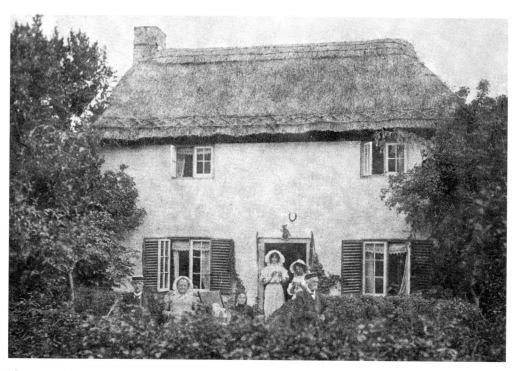

The Maypole Inn at Stoke in around 1910.

Originally titled 'Old Farm', this image is believed to have been Budd's Farm in Yew Tree Road. There is nothing to date the image.

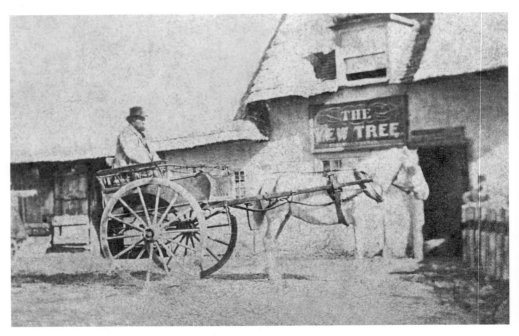

The Yew Tree Inn sometime around 1900. The back of the seat and topsides of the cart indicate that it was for domestic rather than farm use.

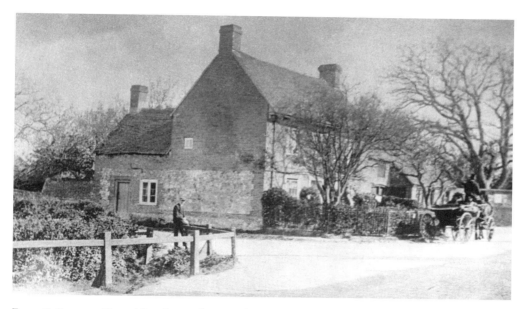

Forge Cottage on Havant Road, seen here in about 1910, was believed to have inspired the author Frank Dilnot to write *Love and the Forge*, but this has not been authenticated.

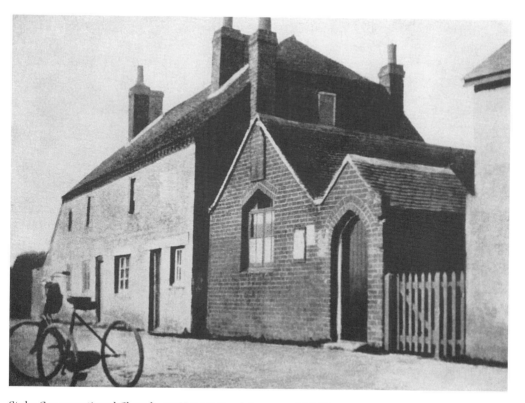

Stoke Congregational Church, on Havant Road, in around 1910.

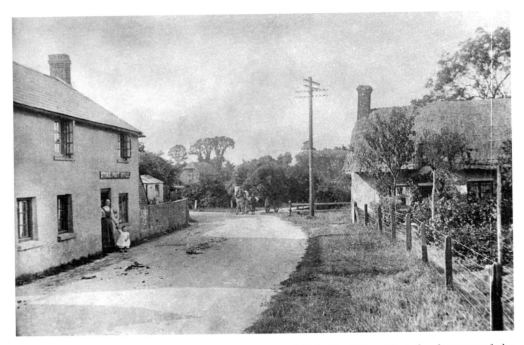

Stoke Post Office opposite Castleman's Lane in about 1910. The little girl at the doorway of the Post Office was later Mrs Cleave.

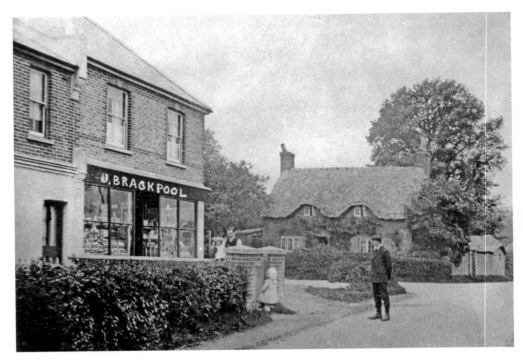

J. Blackpool's shop at White's Corner in about 1910.

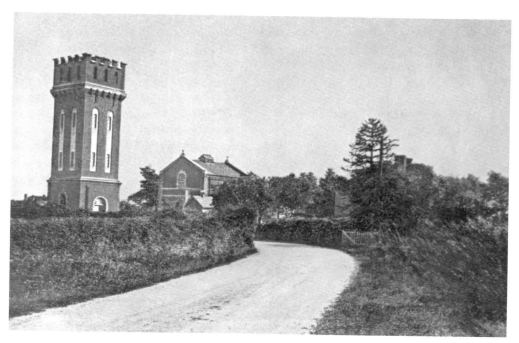

The water works, seen here in about 1930, with the water tower and pump house. Owing to Hayling being so flat, water had to be pumped to the top of a tower to obtain a pressure sufficient to supply water to the extremities of the island. The water was extracted from a well, fed by an underground river believed to originate from a source in Spain.

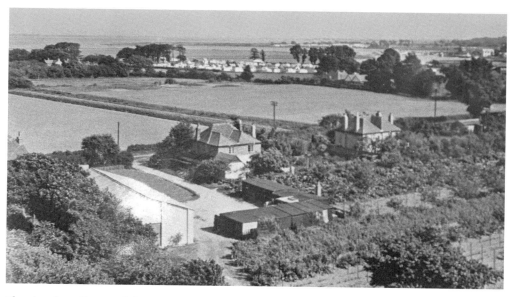

The view from the top of the water tower looking south-east over Chichester Harbour in about 1930. In the middle distance is the Sunshine Camp, and in the far distance an outline of Coronation Camp can be seen.

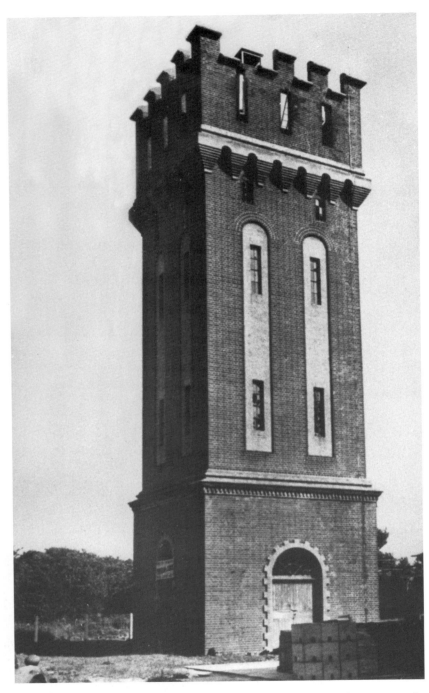

The water tower in about 1930. During the Second World War, the water works was used as a fire station under Fire Officer Mr Radford. During the war there was a siren fitted to the top of the tower to sound air-raid warnings. The tower was demolished in 1952.

7

NORTH HAYLING AND NORTHNEY

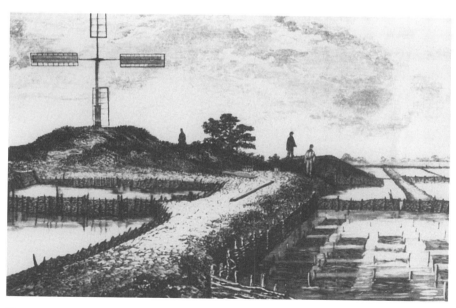

The oyster beds on the north-east shore, shown in a drawing from around 1820, were reputed to produce excellent oysters. The wind sails no doubt powered a pump to circulate sea water around the beds.

The toll bridge linking the island with the mainland was opened by the Duke of Norfolk on 8 September 1824. A five-ton traffic restriction was imposed in 1954 as a result of which only five cars were allowed on the bridge at any one time and only fifteen passengers were allowed to cross on the bus; any excess passengers were required to walk the bridge.

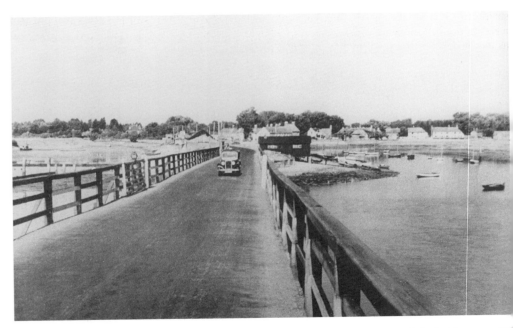

The same bridge in about 1935. The black hut was used as the toll house, and the bridge was still in operation until it was replaced with the present one in 1956. The same tolls were still charged until April 1960.

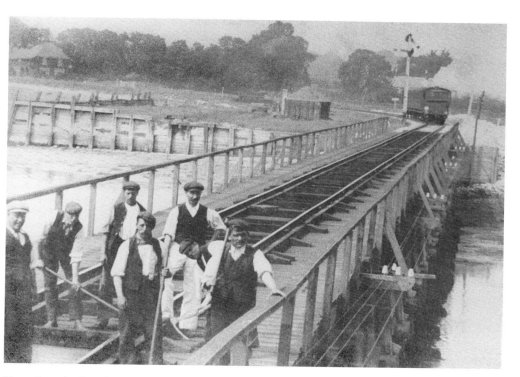

The railway bridge, shown here in about 1900, was near the road bridge. The construction of the line started in 1860, but owing to financial difficulties it was not completed until 1867, when it provided a link from Hayling to the London, Brighton & South Coast Railway. The train affectionately known as the *Hayling Billy* had just passed over the bridge.

The swing-bridge portion of the railway bridge seen here in about 1900. This enabled sailing vessels to pass between Langston and Chichester Harbours. The road bridge can be seen on the right of the photograph.

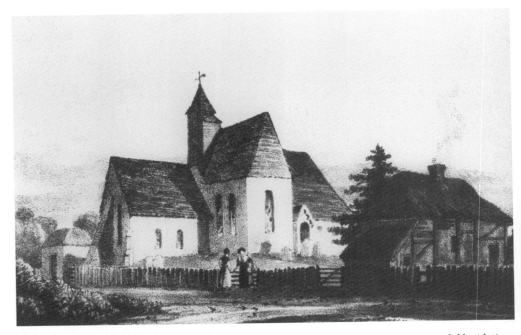

The North Hayling Church and parsonage in about 1820. The parsonage was in a state of dilapidation, and after damage caused by a gale it was pulled down in 1828.

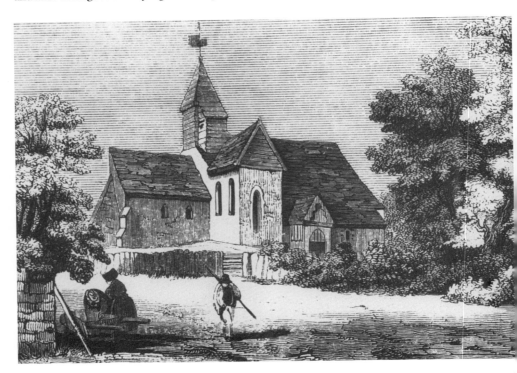

St Peter's Church in about 1820.

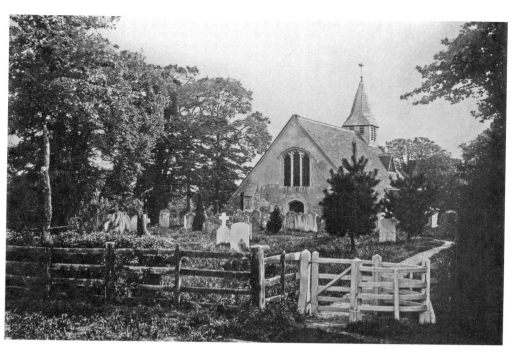

St Peter's Church at the turn of the twentieth century.

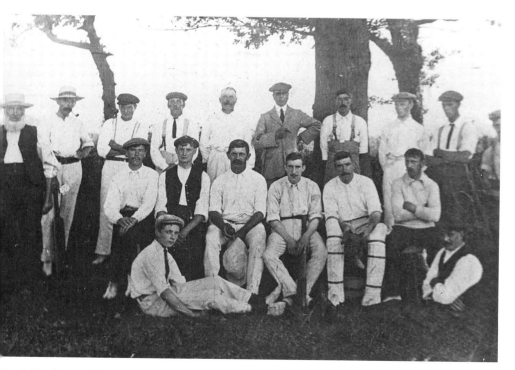

North Hayling Cricket Club on 8 July 1911.

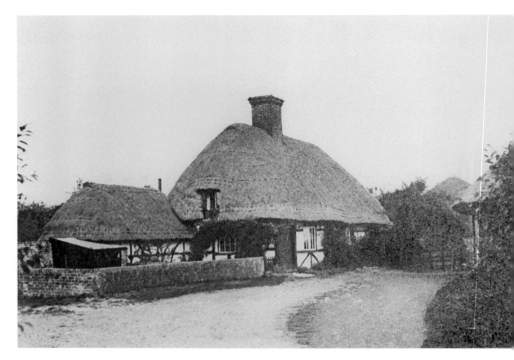

Church Farm Cottage in about 1920.

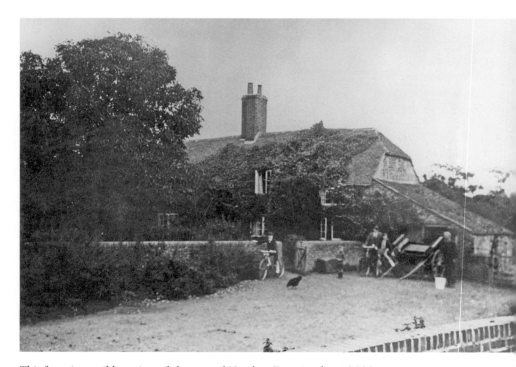

This farm is possibly a view of the rear of Northey Farm in about 1930.

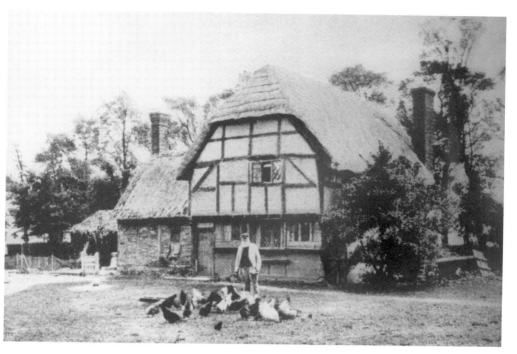

Monlas Place, seen here in about 1904, was believed also to have been known as Dollery's Farm.

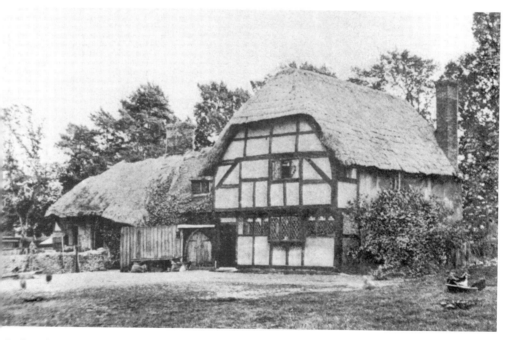

Monlas Place in about 1906. It was destroyed by fire in 1920. There is some dispute over whether Monlas Place was in North or South Hayling.

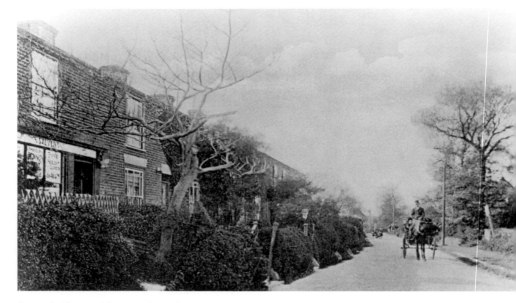

Steven's Shop in Thorney View Terrace *c.* 1910.

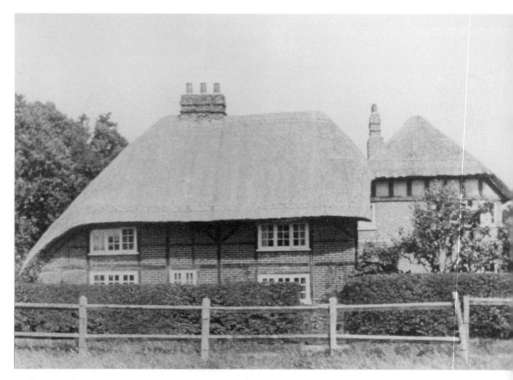

Meadow Sweet in Church Road, seen here in about 1945, was thought to have been 300–400 years old, and served as a private canteen serving up to eighty suppers to naval personnel from HMS *Northney* daily.

8

HAYLING CAMERA
AND CINE CLUBS

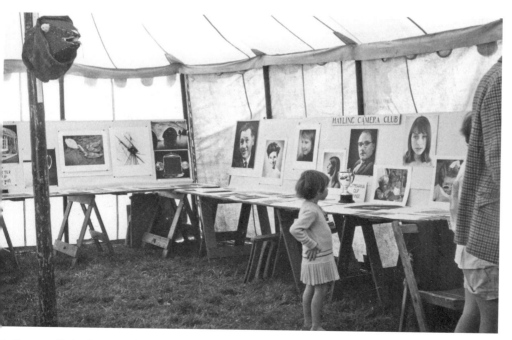

A Camera Club photographic exhibition at the Hayling gymkhana in 1966. The dinosaur's head attached to the tent pole had been part of the club's entry on a previous carnival float.

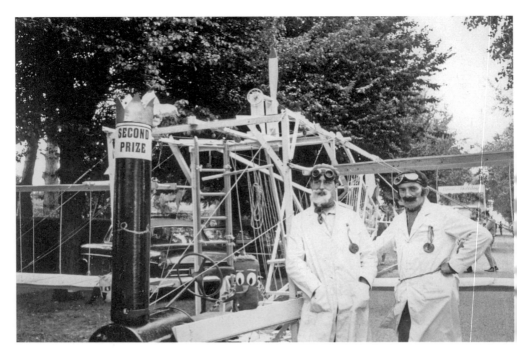

Those 'Magnificent men in their Flying Machine'; the Camera Club's entry in the 1966 carnival. The wings could be raised with a system of pulleys so that the float could negotiate the narrower roads on the procession route.

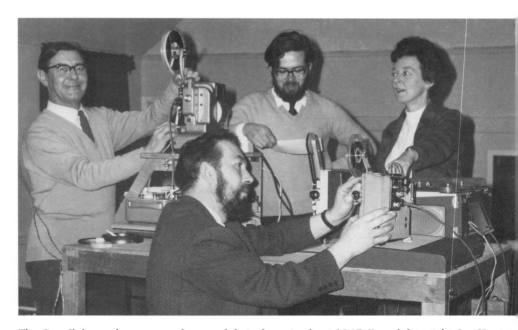

The Cine Club members prepare for one of their shows in about 1967. From left to right: Ian Hunter; Peter Robinson; Michael Rolfe; and Eileen Robinson.

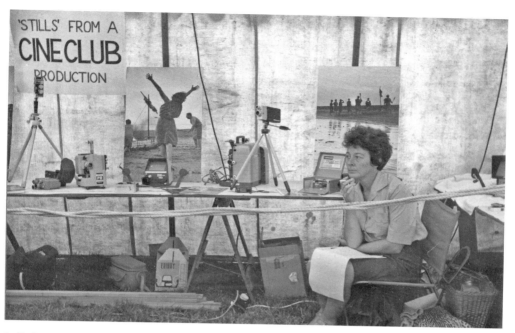

Stills from a Cine Club film exhibited at the gymkhana in 1966. Eileen Robinson contemplates the script for the next film production while waiting for the gymkhana to open.

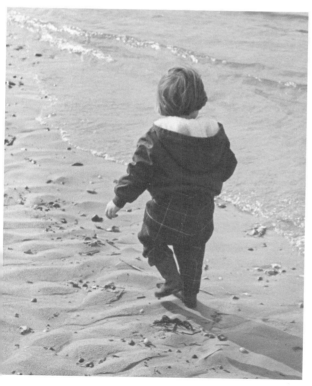

The author's daughter strolling along the Hayling seashore in 1965, a pleasure in any season, and bringing back happy memories of the island.

If you enjoyed this book, you may also be interested in ...

Havant & Hayling Island: Britain in Old Photographs
ROBERT COOK

This fascinating collection of photographs, many of which are from private collections and never previously published, documents dramatic changes around Havant, Langstone and Hayling over the last hundred years. Robert Cook has created a memorable picture of this community by emphasising the importance of people and everyday life, weaving into his captions many entertaining anecdotes – often told in the words of local people themselves. The result is a book that will give pleasure to everyone who knows the area, residents and visitors alike.

978 0 7509 1317 1

Hampshire and Isle of Wight Folk Tales
MICHAEL O'LEARY

These beautifully told folk tales, brought vividly to life by Marcel O'Leary's graphic illustrations, have been collected by the author over his years of working as a greenkeeper, gardener, teacher and storyteller in Hampshire. Many are published here for the first time, and others have evolved through countless retellings in Hampshire schools, festivals, fêtes and events. Featuring dark tales of murderous kings and commoners, wild women, screaming skulls, galloping plague coaches, dragons dancing themselves to death, giants, and wandering corpses, combined with humorous stories and evocative tales of love, lust and passion, this book takes the reader beyond the written page and reveals the wonders that lie within the Hampshire landscape.

978 0 7524 6123 6

Hampshire Past & Present
RUPERT MATTHEWS

From the historic county town of Winchester to the coastal ports of Southampton and Portsmouth, and from the rural villages of the New Forest to the market towns in the heart of the county, Hampshire is a unique and varied county with a rich cultural heritage. *Hampshire Past & Present* contrasts a selection of 100 old photographs alongside modern ones taken from similar locations, to demonstrate the changes that have occurred in a scene over the intervening years. Fascinating images of city centres, housing, shops, and people at work and play bring Hampshire's history to life. It is a captivating insight into the changes and developments that have taken place over the years.

978 0 7524 5816 8

Visit our website and discover thousands of other History Press books.

www.thehistorypress.co.uk

The History Press